Coming to Terms

Number 2 The Charles and Elizabeth Prothro Texas Photography Series

Coming to Terms
THE GERMAN HILL COUNTRY OF TEXAS

Photographs by Wendy Watriss and Fred Baldwin

Essay by Lawrence Goodwyn

Texas A&M University Press *College Station*

The paper used in this book meets the minimum requirements of the
American National Standard for Permanence of Paper for Printed Library
Materials. Z39.48–1984. Binding materials have been chosen for durability.

Library of Congress Cataloging-in-Publication Data

Watriss, Wendy, 1943–
 Coming to terms : the German Hill Country of Texas / Photographs by
Wendy Watriss and Fred Baldwin ; essay by Lawrence Goodwyn.
 p. cm. — (The Charles and Elizabeth Prothro Texas photography
series ; v. 2)
 ISBN 0-89096-386-X
 1. Texas Hill Country (Tex.)—Description and travel—Views.
 2. Texas Hill Country (Tex.)—History. 3. German Americans—Texas—
Texas Hill Country—Pictorial works. 4. German Americans—
Texas—Texas Hill Country—History. I. Baldwin, Fred, 1929–
II. Goodwyn, Lawrence. III. Title. IV. Series.
F392.T47W38 1991
976.4'00943—dc20

 90-20989
 CIP

**Was Du erbst von Deinen Vatern,
erwirb es, um es zu besitzen.**

What you have inherited from your fathers,
Earn that anew, so that you may own it.

—GOETHE
 Pioneer Monument, Landa Park, New Braunfels, Texas

Contents

Coming to Terms

1.

1845–1935: The First Three Generations

THIN SOIL. Sparse trees. A landscape strewn with rocks.

They began with the rocks. With the rocks they built houses, barns, and fences.

All that was asked of them was their labor.

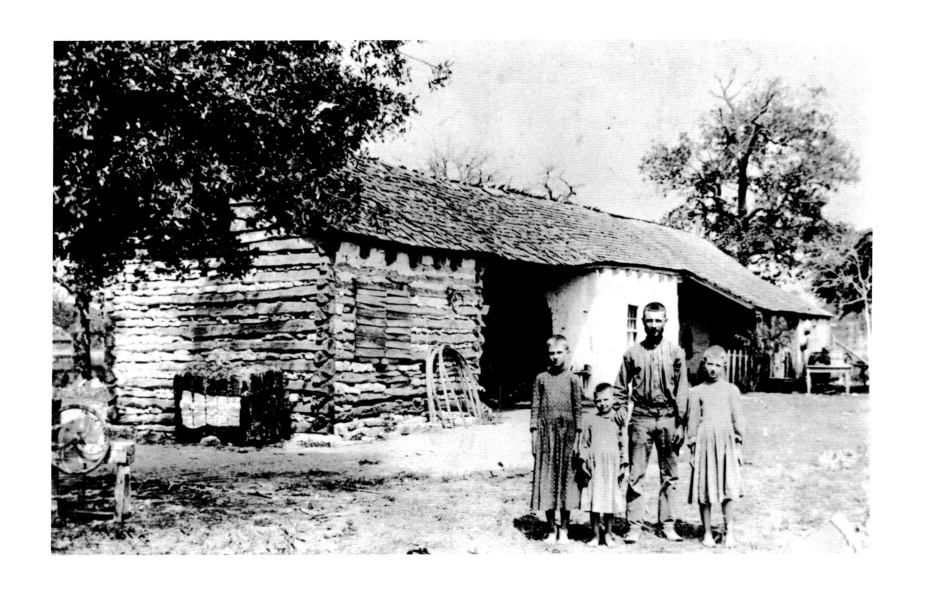

Live Oak settlement, Gillespie County

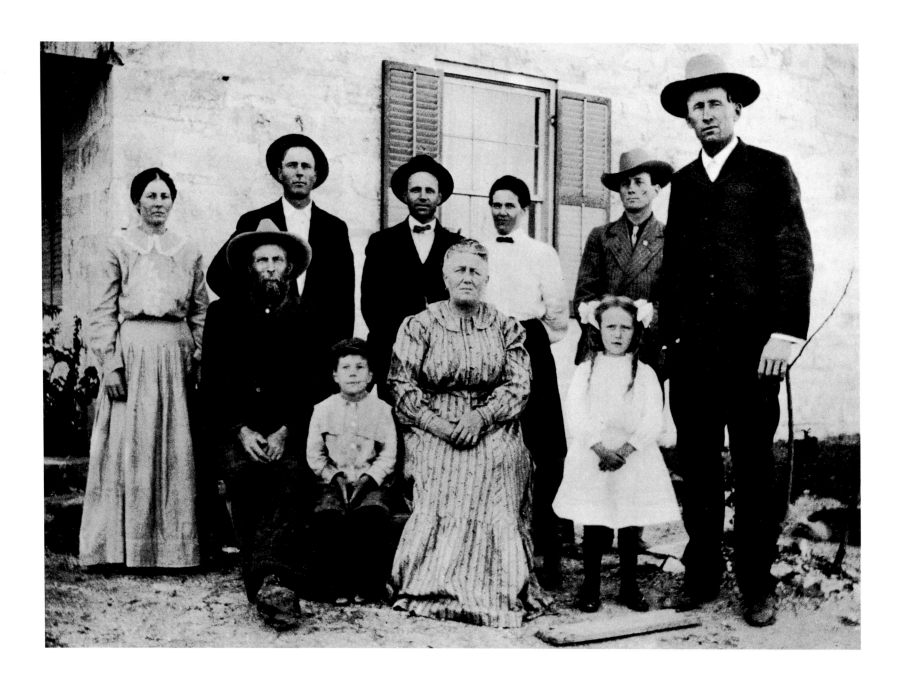

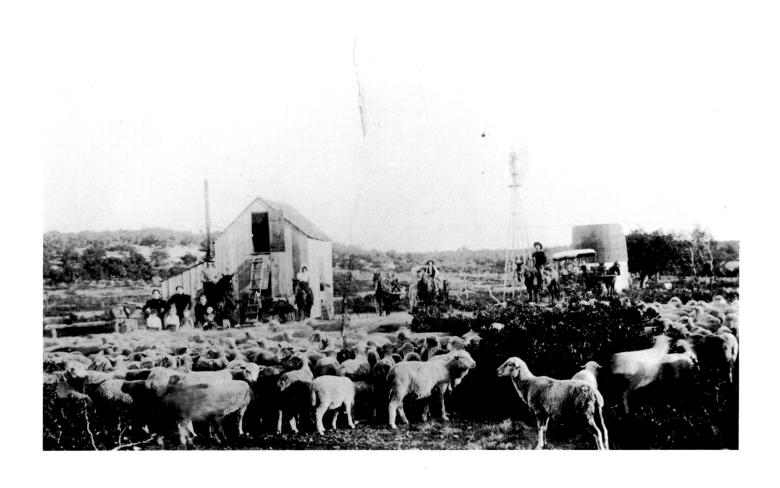

The Carl Durst family

Sheep ranch, Edwards Plateau

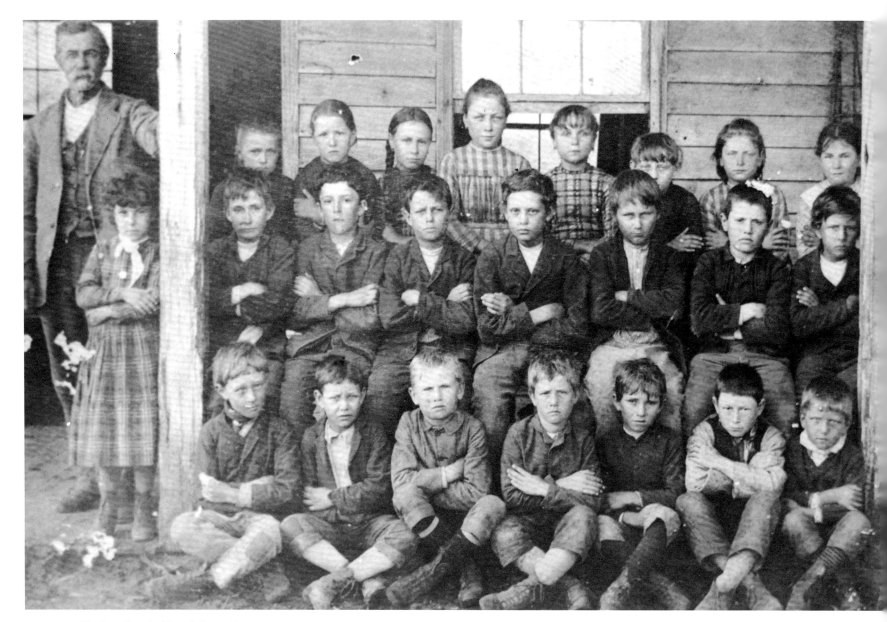

Early school, Guadalupe County

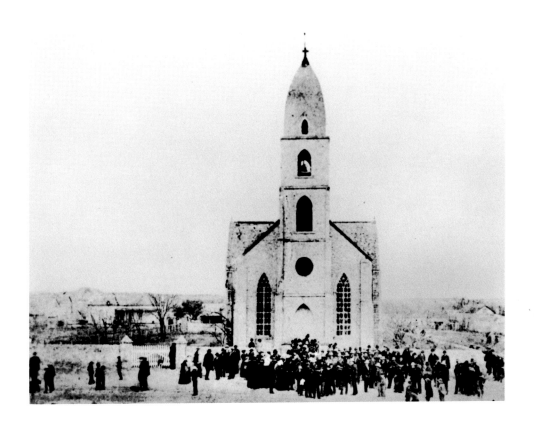

The "Marienkirche," St. Mary's Catholic Church, Fredericksburg

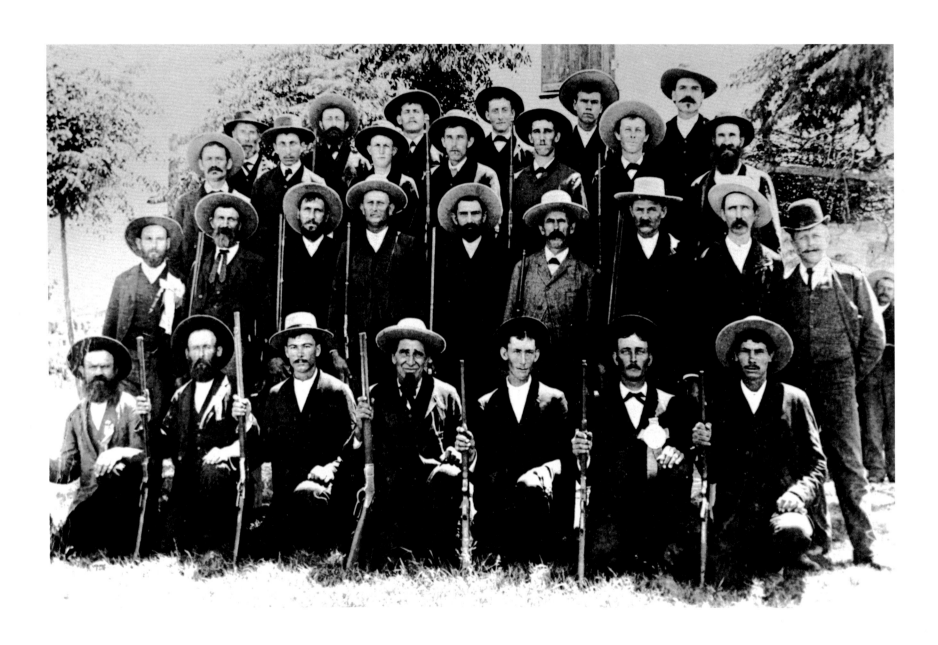

Schuetzenbund, marksmen's association

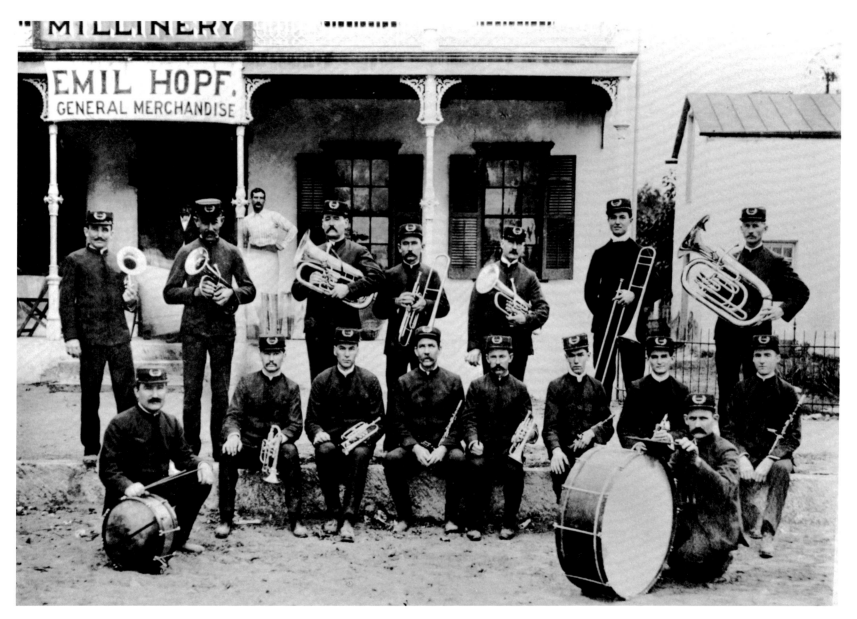

Brass band, Fredericksburg

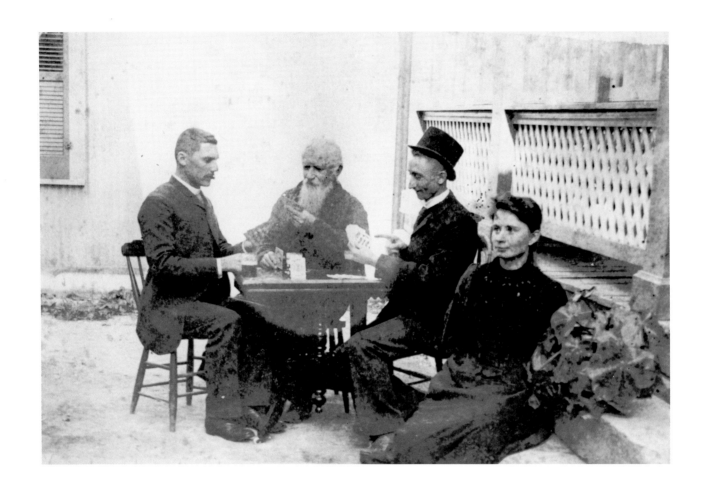

Card game, New Braunfels

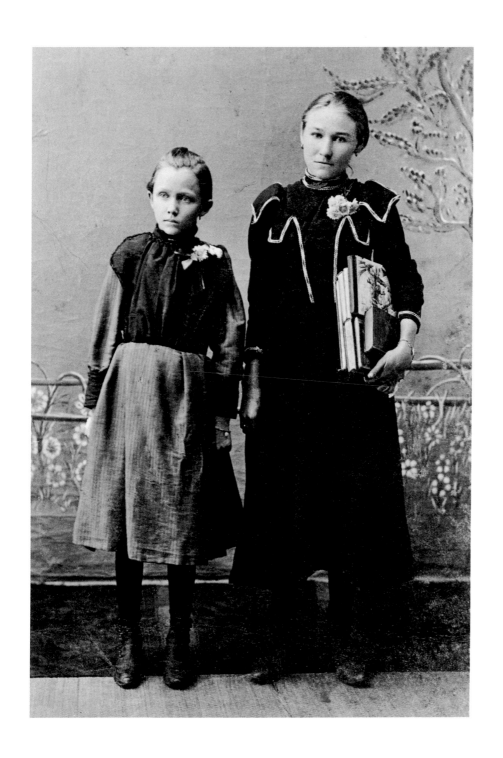

Sisters, Mason County

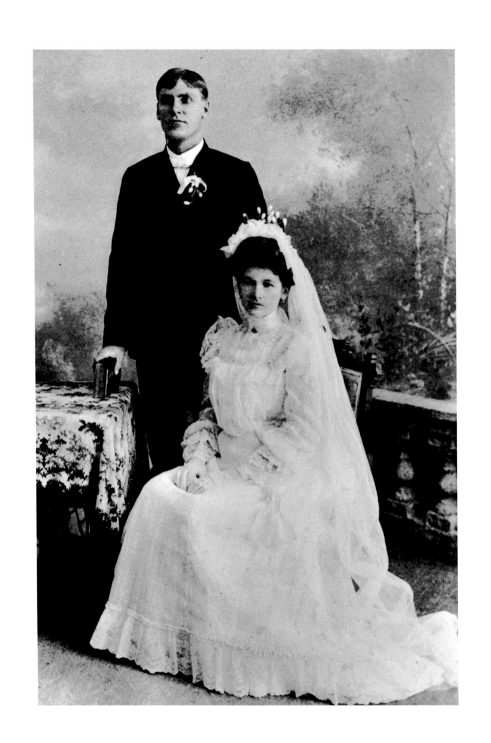

Wedding, Gillespie County

Second generation, Gillespie County

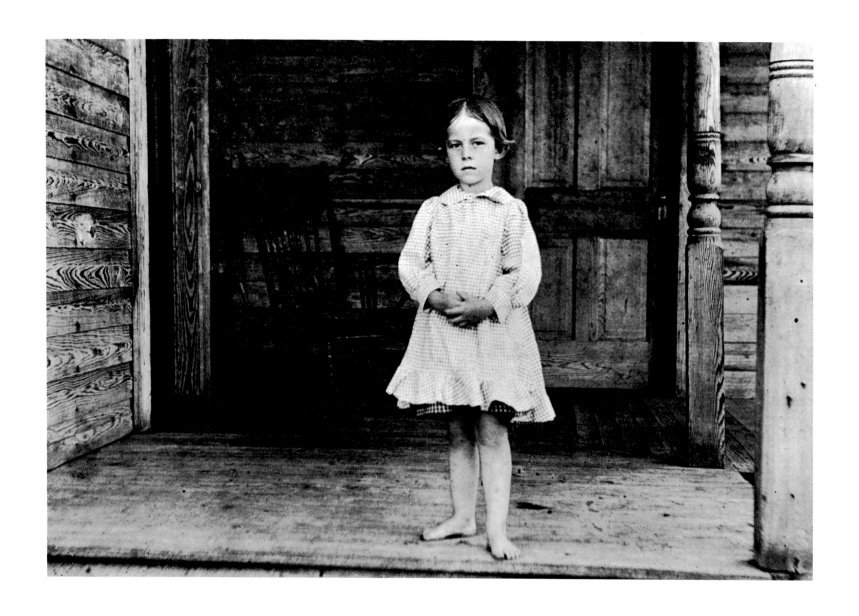

German homestead, Edwards Plateau

2.

The Hill Country of Texas

Lawrence Goodwyn

IT IS A DECEPTIVE PLACE, yielding its truths grudgingly, offering one prospect to passing strangers and another to its occupants. Over time it changes what it offers, takes back what has been given, letting people learn as best they can that nothing comes easily here. It is not surprising then that the Hill Country always calls forth words of description rarely used in combination: harsh and beautiful, resistant and promising, stubbornly appealing. Clearly it is a special place.

But its most grudging truth is not that it is unique or even significantly different, but that its meaning, when finally glimpsed, tells us something organic about the American experience. This connection doesn't leap out at the passing stranger. Indeed, it doesn't leap out at residents, either. Modern Hill Country people, like their forebears, tend to concentrate on what is in front of them, leaving little time to search for subtle meanings about "America." It is a quiet state of mind, undisturbed by the dynamics of self-promotion.

In spite of this custom, or conceivably because of it, the Hill Country has acquired a renown that extends far beyond its immediate area. Contemporary Texans harbor an intuition that something substantial courses through the Hill Country and informs its memories with a coveted authenticity.

Hovering over this intuition is a particular kind of intense American longing that finds expres-

sion in a long-established national legend—a legend grounded in historical events but so refined, redefined, and richly romanticized by each successive generation of Americans that it has become a kind of capitalized national memory: the legend of the West, the legend of the frontier. It is a primitive morality play of good and evil that, over time, has attained a mythic level of emotional power. Acted out in a modern setting, the legend takes diverse forms, harmless, useful, and dangerous. It shows its hand in barroom brawls, in fraudulent popular songs, in bizarre dress codes, and sometimes in foreign policy. It can also on occasion encourage a certain poise under stress, a certain "manly" stoicism, and, in one of its more winning forms, a quiet straightforwardness of manner and belief. But at its deepest level, the appeal of the western legend is moral: a meritocracy of human striving where hard work prevails over all hazards.

To many Texans, the Hill Country has come to represent this strong, vestigial idea of frontier— a place not so much untouched as uncontaminated. And so it is when someone like Waylon Jennings sings about the West and coming home, he draws upon the Hill Country to do so: "Luckenbach, Texas." And the regional image acquired national exposure when LBJ, born in the Hill Country, became an American president and the nation's White House became for a time a white ranch house on the banks of the Pedernales River. Taken in all its parts, the region seems to contain a veritable coupling of American myth and American fact.

But it takes a while to sort it out. We no longer live in a time that instructs us easily in how to understand a place like the Texas Hill Country. We enter it now along four-lane highways and barely notice when we have passed over the Balcones Escarpment and have intruded into the Edwards Plateau. It is not a high mountain climb. Modern travelers can speed through, perhaps notice its peculiar beauty, and miss its mystery altogether. One has to slow down to catch the Hill Country, to slide back in time to other days when poorly built roads curved around limestone outcrops and dipped clumsily into arroyos—and to still older times when the trails went only where iron-wheeled wagons could survive. Some help from history is needed to make sense of the Hill Country.

For a very long time, the Anglo-Saxon experience on the North American continent consisted of standing in the old place, called "the East," and gazing speculatively at a new place called "the West." Anglo-Americans would see the Hill Country only after groping and hacking their way for ten gen-

erations through hundreds of miles of forests and swamps—after crossing the Mississippi and the Sabine and finally the piney woods and blackland prairies of Texas. When travelers came from the East, the Hill Country stared back at them from above and behind the Colorado River: a craggy limestone escarpment once thrust 600 feet above the prairies by some shuddering upheaval now lost in geological time. The surface of the limestone, beaten down by plains winds over thousands of generations, stood barely 150 feet high, but where the river had cut through the limestone to hew it into a solid cliff, it was a forbidding barrier. If a farm family had come from Alabama, Tennessee, or even Louisiana, the sudden appearance of that limestone plateau confronted them in a way nothing else on the plains had.

If they located a ford and crossed the Colorado and then found a way to snake up the first line of rocky hills, they caught yet another vision: a country of canyons and mesas that stretched for miles and ended in yet another line of hills. If the topography wasn't sobering enough, frontier stories about the savagery of Comanches hovering in the hills provided the final deterrent. It did not take much of this before many Americans started to look for another way west.

They were not the first to turn back. For two centuries, the Hill Country was not a land of its own, but rather a small part of a much larger empire known by a single word, Comanchería. The Comanche will-o-the-wisp taught the Apaches, then the Spanish and Mexicans, what they would later teach the Anglo-Americans—that no one could fight from horseback as they could. Until well into the nineteenth century, the Comanches were the only people who could cope with the Hill Country on something approximating equal terms. They traveled over it lightly, asking not too much of any one portion, sampling nature with respect, and leaving the grass essentially as they had found it.

With the founding of the Texas Republic a deliberate attempt was made to create an agricultural barrier between the Comanche world and Anglo settlements south and east of the Plateau. And so it was that German immigrants of the mid-1800s would find themselves between two alien cultures on the Hill Country frontier.

In ways that intrigue and baffle cultural anthropologists, fears grounded in memories of ethnic combat haunt the minds of humans for many generations after the climax of racial rivalry has passed. In this sense, the Comanche contribution to the hidden anxieties of Hill Country people persists today in invisible ways, submerged and blended with a more general knowledge that life has been hard and

insecure on the Edwards Plateau and that people, accordingly, have had to labor and strive with special urgency.

From the 1850s to the 1870s, German newspapers in the Hill Country carried weekly stories of incidents between settlers and the Comanches. In the 1920s and 1930s, when Hill Country people talked about contemporary hard times, they still carried memories of even harder times in their childhood and of the hardest times of all—the times their parents lived through in the nineteenth century. In those days, the full moon was the "Comanche moon." It gave fear a lunar regularity. As the Hill Country oral tradition came down to Mary Nunley, "People were always on the alert and watching for the red men. If we children went to the spring to get a bucket of water, we watched all the time to see if an Indian came out of the brush or from behind a tree. We lived in constant dread and fear. . . . My mother said she had suffered a thousand deaths at that place. . . . Why men would take their families out in such danger, I can't imagine."

Why indeed? In eastern Texas, where the oaks and pines towered in the sky and the limestone was buried under hundreds of feet of blackland soil, there was plenty of room for aspiring farmers in the 1840s and 1850s. Later, in the 1860s and 1870s, when the best of these valleys were fully settled, one could still acquire arable land for prices that seemed wildly inexpensive to Americans on the east coast. Why, then, did men take their families into a world where plows smashed against limestone an inch beneath the surface? Why go into Comanchería at all when elsewhere living was safe and the land not marginal?

The German immigrants came because there was trouble in Europe. Trouble with the potato blight, with the military draft, with overpopulation, and because the spread of industrialization had begun to undercut the home industries upon which so many European farmers depended for the supplementary income that meant the difference between dignity and peonage. People also came because they wanted land of their own. These circumstances produced reasons why people would cast their lot on a desperate overseas migration. But farm families also came to the Hill Country because they were lured there by land promoters, by railroad and steamship companies, by people who wanted to make money.

Here the Hill Country becomes part of the larger American experience of westward expansion. For three hundred years, from the time the first coast-bound colonists in Massachusetts and Virginia

peered inquisitively toward the setting sun, land speculation has been a constant of American life, pulling surveyors and land boomers ever westward, where they could beckon their farmer-customers to follow. But it is not just that promoters promoted . Everyone promoted, whether his occupation was hunter or trader or back-country merchant or steamboat captain. His name might be (in chronological order) George Washington or Davy Crockett or Baron von Meusebach, but the operative philosophy was the same: more people meant more tickets, more title deeds, more trade, more money.

As land west of the Mississippi River was settled, as industrialization proceeded and the railroads began to pierce the plains, speculation grew more sophisticated, but it hardly changed in its underlying drives. The good news about the West spread back along the railroad tracks to the East, to the counting houses in the Atlantic seaports, to steamship companies, to brokers in cities along the European coast, to hawkers who fanned out among the peasants and artisans of the Old World. Scandinavians, Poles, Italians, and Germans all heard the message or read it in their own language in brochures printed by land syndicates, by railroads, and by steamship lines.

The complicity was general: novelists extolled the fertility of American soil, and promotional literature found its way into newspapers as reportorial fact. The location of "the good place" or "the good land" in America changed as the tide of settlement moved steadily westward: Baltimore was a good place, and then Cincinnati and Chicago; Ohio had good land, then Iowa. The translations were paid for by the Chesapeake & Ohio Railroad, then the Illinois Central and the Northern Pacific, or by foreign steamship companies in half a dozen countries.

The good news about the Texas Hill Country was printed in German and paid for by Prince Carl von Solms-Braunfels. Texas soils, he told readers back in the Fatherland in the 1840s, were among "the most fertile in the world." Acting out the role of impresario that men like Stephen F. Austin and Ben Milam had acted out before them, Solms-Braunfels, Von Meusebach, and other speculators created the Verein Zum Schutze Deutscher Einwanderer in Texas (the Society for the Protection of German Immigrants in Texas). The Adelsverein, as it was called, was organized by wealthy and titled colonizers who hoped to make a profit through careful selection of both land and colonists; a successful colony would cause the value of the promoters' lands to soar.

Although the terms for joining the colony were clear, the actual transactions between the Adelsverein partners and their emigrant recruits are shrouded in mystery, chicanery, incompetence, and

some awesome deception by land speculators. On paper, the arrangement went like this: single men were to pay $120 and married men $240. They would agree to cultivate at least 15 acres for three years. In exchange, the Adelsverein would provide free transportation, 160 acres of land for single men and 320 acres for families, a free log house, all provisions necessary to begin farming, credit that extended through the harvesting of the second crop, and all basic public facilities such as schools, churches, and hospitals. This near-miracle of subsidized frontier development was to be achieved on a capital of $80,000 invested by the Adelsverein entrepreneurs. But it was also to be augmented by upwards of half a million dollars collected from seven thousand immigrants who signed on with the colony.

The lure was 1.7 million acres of land deeded to Solms-Braunfels and his partners in 1844 by a land agent named Henry Francis Fischer. A German turned Texan, Fischer, together with another German-Texan entrepreneur named Burchard Mueller, had acquired a conditional grant of three million acres from the Republic of Texas in the early 1840s—conditioned on placing some six thousand settlers on the tract within two to three years of issuance of the contract. The holdings of Mueller and Fischer became known, with a bit of anglicizing, as the Miller-Fisher Grant. Their grant contained a small portion of marginal, semiarid land along the upper Llano River in west central Texas and more than 2.9 million acres of bleached landscape that stretched across far west Texas.

None of it had ever been seen by Solms-Braunfels and his Adelsverein partners when they met with Fischer in Germany in 1844 and paid the enterprising speculator over $11,000 for roughly half of it. On an inspection trip to Texas, Solms-Braunfels landed at Indianola and got as far inland as San Antonio, where the Spanish had stopped, and seventy miles northeast to Austin, where the Anglo-Americans had stopped. Solms-Braunfels, newly enlightened by some sober military appraisals of Comanchería offered by Texans, stopped too. He didn't embark on the arduous trip necessary to carry him on to the remote Adelsverein lands, which began one hundred miles from any frontier settlement. Nevertheless, he wrote numerous reports to Germany about the beneficence of Texas soil.

The colonization process began late in 1844. So distant was the tract from the Texas seacoast that when the first group of colonists—almost all of them quite poor and many of them sick—arrived in Indianola from Germany, there was no way to get there. To accommodate the seven hundred settlers in the first contingent from Germany, the Adelsverein was forced to purchase land on the coast to serve as a temporary settlement and additional lands in central Texas to serve as a way-station. In 1845, the

new tract in central Texas became the site of New Braunfels, near San Antonio. There, the settlers faced the prospect of surviving the first year on tiny plots with almost none of the promised accoutrements and precious little capital of their own.

What they did bring was a beleaguered but deeply felt sense of community and an enormous capacity for work. Almost no one had all the tools needed, even for simple survival, but collectively they had barely enough. Axes, hammers, and saws were passed around. Those with plows planted early; those without planted later. Rude log houses were constructed closely together, creating a nuclear settlement, while the farmland for each colonist was located in areas outlying from the village. Individual holdings were a minuscule 10 acres or less, far below the promised 160 to 320 acres.

Solms-Braunfels talked bravely about overcoming the land shortage by teaching the Comanches a lesson, but as he became better informed about the Indians and the arid features of the Adelsverein grant, he directed his frustration at Fischer. The latter, it seems, had not been entirely candid in his description of the grant. Finally, Solms-Braunfels, beset by a tangle of administrative and creditor problems, decided to resign and return to Germany, leaving the project in the hands of an Adelsverein partner, Baron Von Meusebach.

In New Braunfels, Von Meusebach found an empty treasury and a colony in disarray. To make matters worse, the Adelsverein had shipped another 4,000 German colonists to Texas. When they arrived in the winter of 1845–46, there were no provisions or transportation to take them on to New Braunfels. For months they had to camp on the humid, rain-soaked Texas coast in makeshift tents and shelters. By the time Von Meusebach found wagons and horses to take them inland, many had died of fever, and an epidemic was beginning to rage among them. That spring and summer of 1846 the fates were not kind: in New Braunfels, 400 German settlers died; another 250 died on the coast; and another 100 died on the way inland.

In desperation, a small group of survivors—still fearfully undercapitalized but at least alive—pushed out from New Braunfels into the Hill Country on the first leg of a journey they hoped would take them to the distant lands that they thought were theirs. They found the going extremely difficult, and signs of Indians became more frequent. Eighty miles short of the grant, they stopped in a small valley that Von Meusebach had scouted and surveyed several months earlier. There, within range of Comanche scouting parties, the Germans laid out a market square and a wide main street and threw

up tents. They named the site Friedrichsburg, later anglicized to Fredericksburg.

It would be another half-year before Von Meusebach clawed his way beyond Fredericksburg and the upper Llano River into the desolation that was the Miller-Fisher grant—and another year before the grand scheme fell apart, before the colonists learned conclusively that their landholdings were worthless. In these intervening months, the desperate experience of New Braunfels was repeated as successive waves of settlers arrived from Germany, pushed out along the upper Guadalupe River, and moved north past the Pedernales. The whole Fredericksburg region lay far beyond the line of previous American settlement. The impoverished German families so recently removed from Hannover, Hesse, Brunswick, and Heilbronn had become in themselves an American frontier. They stood virtually naked before the Comanche nation. As a new arrival in Fredericksburg wrote to a friend in New Braunfels in 1846, "No one, especially not a family, should be exposed to a wilderness where everything is lacking."

Once again, tools were passed around; once again, fields were plowed in sequence. The struggle around Fredericksburg grew even more desperate than that of the previous year because the Adelsverein managers were under great pressure to meet the state-imposed deadline for putting six thousand settlers on the grant. To pack as many emigrants as possible on each ship leaving Germany, the Adelsverein had advised its recruits that supplies, implements, and other encumbrances were not needed. In the fall of 1846, a hundred settlers died in Fredericksburg, and the estimates reached as high as two thousand for New Braunfels.

When the spring of 1847 brought final confirmation of the hopelessness of the Miller-Fisher grant, the Adelsverein gave up its idea of colonizing Texas. The options open to the German settlers disappeared. The geologically weathered, 24,000-mile limestone plateau was to be their home—if they could make it so.

It is frightening to add up, piece by piece, the human and natural forces arrayed against the thin vanguard of German immigrants who settled the Texas Hill Country in the middle of the nineteenth century.

The trouble lay in the land itself. The soil, as it turned out, was surprisingly thin, the stone outcrops everywhere, the rainfall precarious. The true scope of the challenge could only be understood over time—after three crops, or five, or twenty. The land was not only untillable where it was visibly

hilly, but it was also hilly where it appeared to be flat. Grass "as high as stirrups" waved in the wind with pleasing symmetry that made the landscape look level, but when the grass was burned and cleared for plowing, the "pasture" too had often vanished. The land was maddeningly uneven, not every ten yards or so, but every yard, sometimes every foot. And when the rains came, the water cut along the unevenness, washing the inch-deep soil away, revealing a field suddenly strewn with rocks. The grass had concealed some frightening truths.

In all but bottomland pastures where topsoil had accumulated over hundreds of years, the grass should never have been plowed. This was one of the most sobering discoveries: the tall grass, which had derived from a painfully slow process of new grass growing out of old, generated a padding that held the dirt and the rain and thereby created a thin, fertile layer of soil that rested on top of the limestone plateau. The grass and the matted turf that supplied the padding underneath it had been the product of centuries of natural evolution. It could all be destroyed in a day of plowing.

The final and most enduring problem was rainfall: the Hill Country in its entirety lay beyond the thirty-inch rainfall line—and thus beyond the limits of permanent agriculture. The definition of this break was nowhere more starkly plain than when nineteenth-century travelers approached the Hill Country from the east near the city of Austin. On one side of the Colorado River, which ran along the edge of the plateau, varieties of oak and pine trees grew tall, as they did all the way east to the Atlantic Coast; on the western side of the river, trees quickly shrank in size until they became clusters of spindly bushes. Seventy-five miles deep into the Hill Country, what today would be called an oasis economy was all that was possible. That condition lasted all the way to California. In the Hill Country of Texas, the limits of agricultural production on the Southern Plains had been reached. Hill Country farmers would deny it and look for corroboration every year that the rainfall jumped to thirty-three or thirty-seven inches. The inevitably counterbalancing year of twenty, fifteen, and even ten inches of rain was called a "drought" year. It took more than a generation for farmers to accept this pattern as a permanent law of nature on the Edwards Plateau.

Thus began the long German siege of the Hill Country. Decade after decade, German farmers pressed their holdings to the limits, trying to make subsistence farms commercially profitable. They tried many combinations: corn, rye, and wheat; barley, cattle, and corn; corn and a big garden; sheep and a bit of cotton; sheep, goats, and some orchard; cotton in the creek bottoms, Herefords on the

lowlands, vineyards on the hillsides. When the Sons of Hermann met, there was always a new theory about what to try next year.

While Anglo farmers around San Marcos plowed with horses, German farmers around Boerne plowed with oxen. Oxen sapped the plowman's energy and caused maddening inefficiencies in productivity, but oxen cost half as much as horses. And the horse-stealing Comanches left oxen alone. In the years following the Civil War, Anglo farmers to the east around Johnson City had 300, 500, even 1,000 acres; German farmers out from Fredericksburg had an average of 166 acres. The Germans had to rely on family labor and saved by making many of their own tools, even plows. When cotton became the big crop, German farmers got one and two cents more per pound because German farm women removed the dirt from cotton bolls with their lips as they picked it. The cotton fields of west-central Texas became ethnically identifiable: German fields were picked clean, while elsewhere bits of white were left dangling from the cotton plants.

There was a moment in the late 1860s and early 1870s when commercial success appeared within reach. The great cattle drives from South Texas to Kansas could pass through the Hill Country. German farmers did all they could to encourage such passage, renting unused hillside pastures to the drovers. The longhorns came by the tens of thousands, but the cost to the land became all too clear. Each year the hillside grass grew back thinner; each year the erosion from the rain runoff became more perceptible. Even before the cattle trails swung further west, everyone around Fredericksburg learned there would be no bonanzas for them from the cattle drives.

Soon thereafter, German farmers did something that astounded their neighbors: they began to close huge areas of open range with fences—stone fences three feet high. An awed Texas historian described the process:

> Entire families, including small children, labored for months or even years to construct stone fences on their farms, since the prohibitively high prices, ranging from 300 to 450 dollars per mile in the 1880s, prevented most settlers from hiring someone to do the job. . . . Across the flat stream valleys, up the steep hillsides, and over the divides the Germans built them, accomplishing what no other ranchers in the entire West were willing or able to do—fencing the open range before barbed wire. The Kothmann family of southeastern Mason County claimed to

be the first to enclose their entire ranch in this manner, a task which took four years, from 1873 to 1877, to complete, using stone quarried on their land. At Live Oak Settlement in Gillespie County, another German enclosed twelve hundred acres with a stone fence.

The logic behind this frantic fence building became clear. German farmers began to experiment with cattle breeding, first with Durham shorthorn bulls and then with Herefords. Because of their lead in fencing the range, the Germans gained ten years on their Anglo neighbors in marketing improved stock.

Livestock breeding was not restricted to cattle but extended to sheep and goats as well. Wool and mohair yielded more income per acre than cattle and were demonstrably easier to transport from the remote plateau to market. In the first decade of the twentieth century, the Texas Hill Country became second only to Turkey in world production of mohair. The nation took formal notice in the 1930s when *Fortune* magazine did a feature story on a Hill Country man, Adolph Stieler, as the nation's "mohair king."

Gradually, one by one, German farmers let go of their crops—corn, wheat, rye, cotton, and grapes. The Edwards Plateau was for ranchers.

But the Hill Country always struck back. The added grazing on land long weakened by crops and rain erosion proved too much. A new enemy appeared: fast-spreading cedar brush, a desert growth. It gobbled up pasture until whole sections turned dull green and worthless. With cedar came scrub oaks and mesquite, whose fierce roots sucked up available moisture and dried the creek beds until thousands of acres became unusable. But above all, it was the spread of cedar brakes that suffocated the land. The Hill Country was relentless.

On no one did the emotional price of survival fall more heavily than upon Hill Country women. Everywhere in rural America, women carried severe burdens, but in the Hill Country the demands were particularly hard. Family life was rigidly autocratic and dominated by the father. Women were expected to work alongside men in the fields, but men generally did no work in the home. Even so prosaic an object as household water necessitated debilitating labor. German women used well water without windmills because windmills were costly. Wells in the Hill Country were deep, a hundred feet or more, and water had to be lifted by hand to the surface. Loaded, a four-gallon water bucket weighed

over thirty pounds, and while husbands could do the hauling before going to the fields and sons before school, the water so obtained was invariably used up by noon. Women carried Hill Country water, sixty pounds of it per trip, hundreds of feet to the house, many times each day.

Women also did the baking, the canning, the washing and ironing—all with water boiled on wood-burning stoves heated by fast-burning cedar fires that would fill the small stone rooms with smoke . In his vivid biography of Lyndon Johnson, Robert Caro has recaptured the essence of this routine:

> When the big iron stove was lit, logs blazing in its fire, flames licking at the gratings that held the pots, the whole huge mass of metal so hot that it was almost glowing, the air of the kitchen shimmered with the heat pouring out of it. . . . In the Hill Country, summer would last almost five months . . . without a cloud as a shield from the blazing sun that beat down. . . . No matter how hot the day, the stove had to be lit much of the time . . . not only for meals but for baking.

Baking and canning were all-day jobs for which, according to the testimony of one Hill Country woman, "you wore as little as you could. I wore loose clothing so that it wouldn't stick to me. . . . You got so hot that you couldn't stay in the house. You ran out and sat under the trees. I couldn't stay in the house. Terrible. Really terrible. But you couldn't stay out of the house long. You had to stir. You had to watch the fire." For the women, even more than the men, there was a certain fury in the intensity of labor.

"If I had a nickel for every stone I've thrown, I'd be a millionaire," a Hill Country woman remembers today. "We were in the field as much as the men. We'd start early in the morning in the house, then we'd pick, chop, and go back to work in the house. Sometimes it was 2 and 3 A.M. before I'd finish washing the baby clothes after dinner. I was often so tired that I wouldn't hear my children calling for bread, and Willy would have to wake me up."

Life on the Edwards Plateau was not only demanding, it was also remote. Roads were poor and railroads nonexistent. In every generation, the German stone farm houses were refined, the fences lengthened, and the farms improved. Things persistently got fixed up, but things were never quite fixed.

Comparatively speaking, however, Hill Country Germans had an advantage over Anglo farmers in other parts of Texas and the South. In the twentieth century, the power relations between commercial and agricultural America were determined by monetary policies and interest rate formulas fashioned by the financial sectors of the society. The cards were stacked against the nation's farmers. By 1930, half the farms throughout the nation's prime agricultural districts were worked by tenants. Everywhere, increasing numbers of farmers lost their land and descended into the silent, suffering world of tenantry. They became objects of national derision: "hayseeds," "peckerwoods," "wool hats," "rednecks," and, of course, "poor whites." By whatever name, this human specimen proliferated across Texas.

But not among the Germans of the Hill Country. Though prosperity eluded most of them, they in turn eluded tenantry. In this comparative sense, the Germans did well. People thought so and said so. The evidence was unmistakable: the mortgage-free farmstead, the meticulously weeded gardens, the handsome stone buildings, the healthy Herefords, and, above all, the miles of well-kept stone fences. People saw these things, and gradually, as they became conscious of a Southern peasantry increasingly locked into peonage, the Germans came to be seen as "prosperous."

It was a curious turn of events . For nearly a hundred years the minority of Anglo-Texans in the Hill Country and the majority around it had watched the German drama without understanding its meaning. In the very earliest years, German farm families lived barely above the level of subsistence, but they were perceived by their Anglo neighbors as "getting along very well for poor folks." One Anglo man managed to be admiring and patronizing in the same sentence: "They are every year improving on their homes and . . . they farm their little pieces of land first rate."

"Their little pieces of land" . . . "their homes." . . . This was more than the language of ethnic distancing. It betrayed the belief, so deeply held that it rarely acquired overt public expression, that an "American" standard existed by which people and values should be measured. Whether the practices of German farmers were judged to be "first rate" or merely odd, the Germans were perceived as different from their neighbors.

And they were different. They picked up English quickly and adapted Anglo customs to their own culture, but they were proud of their own language and traditions, and they kept them. They

began to publish German-language newspapers only a few years after they arrived in the Hill Country. They believed in education, and they saw to it that the early schools taught both German and English.

They differed from their Anglo-American neighbors in another important way. Most Anglo-Americans moving west after the American Revolution moved as individuals. Though many of them saw themselves as carriers of a new American culture, only a few—mostly religious sects—set forth with the idea of building communities. For most, the driving concern centered on "making it" for themselves and for their families.

But the Germans did not come to the frontier solely as individuals. They came as a group, as a colony, and they were concerned with community. Only a few years after arriving in Texas, the immigrants began to construct a thick web of cultural organizations—not only agricultural associations, but also dancing and singing societies, drinking and shooting clubs, and what was to become an enduring social institution, the Sons of Hermann. At the outset, they fashioned organizations that cost no money; it would be a while before the pioneering generation could afford to augment the singing societies with brass bands. Hill Country Germans sang, drank, hunted, and played cards, and later they created rural festivals and parades that became the wonder of the region: the first county fair in Texas and the famous *schützenfest,* where the products of skilled German gunsmiths in the hands of Hill Country farmers were measured against Anglo legends of frontier marksmen with their Kentucky rifles. As families and communities, the Germans congregated in celebrations that brought a unique and vivid quality to Hill Country life.

For more than a century, travelers were struck by, and unfailingly commented upon, the contrast between the hearty public life of the Germans and the comparative narrowness and thinness of the surrounding "mainstream" culture. The conclusion was uniform: the Germans were getting more out of life than their neighbors were. Everyone felt it, and the most articulate observers spelled it out in detail. The Baptist and Methodist beliefs of the Anglos had something to do with this disparity, of course, but many of the Germans were Lutherans, so sharp differences in the variety and style of community leisure could not be traced simply to distinctions between Protestant and Catholic religion. The communitarian drive of the Germans was a central factor.

It was evident in the way they built. They built things to be enduring. Towns like Fredericksburg were laid out according to communitarian plans that took care to allocate proper space for schools, churches, farmers' markets, public buildings, and meeting places. The area originally set aside in Fredericksburg for a market square was large enough for a city of ten thousand. In 1847 the imperatives of survival were such that only two of the first fifty structures were made of stone. A decade later, only stone houses were being built.

But Hill Country Germans were concerned with more than buildings. Despite cultural differences, the Germans wanted to be an active part of the New World. They believed deeply in the ideals of freedom and opportunity which Americans asserted. Writing to relatives in Germany, an immigrant German pastor wrote from the Hill Country in 1851: "There is no trace of this hatred of the rich by the poor here because even the poorest man can become wealthy here, and actually does if he works hard." The Germans of the Hill Country wanted to join the New World as participants, advancing the values of America and not simply accepting what they found. Within the first six years—before they had secured more than a tenuous hold on the Edwards Plateau—the German settlers began forming associations to put forth their ideas of freedom, not only through newspapers but also through "democratic unions" and "reform unions." These associations sprang up on the Pedernales River and Live Oak Creek, in Fredericksburg, New Braunfels, Sisterdale, San Antonio, and Austin. They soon merged into district-wide monthly meetings for "political instruction." Out of these meetings came the ideas that coalesced in 1854 in a far-reaching and highly controversial document—a statement of "political and social reform."

The statement opened with the words, ". . . we are convinced that the people of the United States do not enjoy the liberties guaranteed to them by the constitution," and it went on to call for reforms that the country would not enact for years to come: free public education from first grade through college, progressive income tax, and abolition of imprisonment for debt. It also called for changes that the country has yet to see: among them abolition of capital punishment and the grand jury system, direct election of the president, and the "equality of labor and capital in all laws relating to them." With the colonization experience fresh in their minds, they also declared that "the soil shall not be an article of speculation, but should be regarded as a means of compensating labor." The German document was, from end to end, a thoroughgoing assertion of democratic principle. In the words of

historian Joe Frantz, it was "a combined statement for the freedom of all mankind."

In terms of public perception, however, all other proposals were overshadowed by the stand taken on slavery, described as "an evil the abolition of which is a requirement of democratic principles." The statement stirred up an immediate and vicious counter-attack that was quickly extended toward all Germans in Texas. It marked a high point in early Anglo-German tension. The *Texas State Times* called the declaration "treason" and announced that the Germans of Texas had departed "from every shadow of that love of their adopted country by which they should have been activated." Even German singing societies were condemned as "revolutionary" and "subversive."

In fact, of course, there was nothing that could be described as a single German political belief. This reality was quickly demonstrated by the variety of stances taken by Germans as America moved toward civil war. Some Hill Country Germans nursed deep abolitionist sentiments, fully expressed, while others adopted an expedient posture of silence, and a few publicly disassociated from the 1854 declaration and recommended on the eve of the Civil War that their countrymen "suppress" any attempt to disturb the institution of slavery.

But everyone was forced to take a stand. Mason County, 60 percent German, voted 60 percent against secession; Fredericksburg and the rest of Gillespie County, 85 percent German, voted 96 percent for the Union. When Texas did secede, hard times were clearly ahead for Germans in the state. Farmers in the Hill Country were reluctant to go into the Confederate Army and leave their families on isolated farms to face the Indians alone. They were, however, ready to join Home Guard units that sprang up in the region. But the Confederate conscription law of 1862 was draconian and class-ridden; it applied to all male citizens between the ages of seventeen and fifty except for every officeholder, including minor local functionaries; men dubbed "indispensable"; and affluent citizens who could hire substitutes. The law was coolly received in a number of places in Texas, but nowhere more coolly than in the German Hill Country.

Texas authorities declared martial law and began confiscating without due process the property of "disloyal" persons. The definition of loyalty became increasingly arbitrary. In Fredericksburg the Confederate officer in charge proclaimed that "the God Damn Dutchmen are Unionists to a man," and he announced his intention to "hang all I suspect of being anti-Confederate." Anxiety among the Germans became universal. In the summer of 1862, a group of sixty-five Germans, men and boys, left

the Hill Country near Fredericksburg for Mexico to escape the draft and eventually join Union forces in New Orleans. They got two hundred miles before being caught near the Nueces River by a pursuing Confederate detachment. Attacked while they slept, about twenty Germans were killed, some shot to death after being wounded and others trampled by Confederate cavalry. The rest got away. The officer leading the assault reported that resistance was "determined" and added, "hence I have no prisoners to report."

News of the Nueces massacre sparked a bitter reaction in the region. Many of the dead were fathers and sons of farm families. Formal calls for an investigation were ignored, and subsequent public demonstrations for an investigation were dispersed in what amounted to a riot by Confederate police. Bloody incidents regarding "disloyal" citizens continued in the Hill Country as elsewhere in Texas, but the Germans felt singled out for punishment.

Political beliefs and allegiances fashioned in the Hill Country during the war included an almost universal animosity toward the Democratic party as the "party of the Confederacy." These beliefs lasted beyond the lifetimes of most Hill Country residents who lived during the era of secession.

But German allegiance to postwar Republicanism was more than mere alienation from Southern Democrats. Ideas that Hill Country Germans had expressed in their 1854 platform became policies that the Republican government of Reconstruction in Texas moved to implement. Led by E. J. Davis, who consistently received the support of German voters in the Hill Country, the Reconstruction administration in Texas passed the most democratic constitution the state had ever had. It also inaugurated the ambitious program of free public education so important to the German immigrants.

Prewar German opposition to slavery also translated into postwar support of black voting rights and, beyond that, to public association of Germans and blacks in the Republican party. In 1871, the platform of the New Braunfels Convention straightforwardly proclaimed the Republican party to be "the party of progress and justice for all races." And again in 1873, amid rising opposition to black political participation and increased Ku Klux Klan activity, the Convention of German Speaking Citizens announced: "We declare ourselves against passage of any law or laws which may aim at the oppression of any class of citizens in this state in regard to race or color."

To the Germans of 1873, as with the Germans of the 1854 declaration, free blacks and free schools represented two aspects of the same egalitarian political tradition the Germans brought with them to

the Hill Country in 1845–46. But in the frenzied climate of Reconstruction, these beliefs placed the Germans at the center of a storm of abuse generated by Democrats and former supporters of the Confederacy. The vilification in the Texas press of all aspects of Republican Reconstruction inevitably discredited all democratic advances instituted in the new postwar constitution. Defenders of that constitution—and none were more articulate than Hill Country Germans—found themselves the object of passionate scorn and political vituperation.

On the heels of the Civil War, the Germans found their most deeply held political beliefs were once again relegating them to the fringes of public life. A letter published in Fredericksburg in 1869 expressed the gathering despair:

> That our populace in general was always quite Unionist is a fact that does not even need to be proven, and it is just as certain that our people are far from having even the slightest sympathies for Rebels and democrats. Nevertheless, it cannot be denied that such indifference toward everything that people call politics has taken over that . . . I would almost say there is a despair that our political conditions can ever improve. If you ask an honest man here . . . why he doesn't take a more active part in politics, his answer will run, "what good is it?" . . . The voice of the "old rebel" who came out of the war rich . . . is a hundred times louder than that of a Union man who stayed poor and is unable to emphasize his opinion with pretty words.

To make matters worse, the Germans then found themselves faced with the growing force of the Anglo Protestant temperance movement. To Hill Country Germans, the right to have a glass of beer or to dance and play cards on Sunday was not only a cherished cultural inheritance but also an inherent part of a political system committed to individual liberties. "God expects you to work hard and enjoy the fruits of your labor," a Fredericksburg newspaper editor explained. The Anglos' blue law movement, which called for closing stores on Sunday, was also viewed as a threat to personal freedoms. A Hill Country representative told his constituents: "The strict Sunday closing law, if enforced to the limit, will deprive the man who spends six days a week earning a living for his family, a day of relaxation for himself and his family. And the farmer who feels the need to drive into town for church is robbed of the opportunity to take care of business at the same time because all the stores are closed."

An exasperated Hill Country editor managed to lay all these difficulties at the feet of the Democratic party, calling it the party of "the K.K.K., Rebels, prohibitionists, Blue Law advocates, NY thieves [a reference to Tammany Hall], deserters from the Republican Party and Jesuits." But it was also the party that would dominate Texas politics for the next seventy years.

Not surprisingly, Hill Country Germans were increasingly isolated in their political activity. Even when their economic values corresponded closely to the economic objectives of the new People's party of the 1890s, the strong prohibitionist leanings of Texas Populists were a barrier to German involvement with the third-party movement. As the Republican party declined in Texas and some Germans began to vote in the Democratic primaries, they supported candidates who reflected their beliefs—opposition to prohibition and the KKK. But their vote was barely noticeable within the overwhelmingly larger Anglo Democratic population. In national elections, they continued their old allegiances and stood almost alone in Texas in their consistent support for Republican presidential candidates. Twice, however, they departed from this custom to vote for candidates whose policies more closely reflected the Germans' earlier beliefs than did the growing corporatism of the national Republican party—Teddy Roosevelt's Progressive party in 1912 and Robert La Follette in the presidential campaign in 1924. "Behind La Follette," wrote a Fredericksburg editor, "stand the laborers of the United States, the farmers of the West, all liberal men who are dissatisfied with the old parties. . . ."

Over the decades, Hill Country Germans kept their voter turnout high—higher than the average—but their impact on public life was minimal. They noted grimly that their ideas had little effect on the political thinking around them. Gradually even the memory of the ideas expressed in the 1854 platform faded away. As a close observer of modern Hill Country politics says: "The old-style republicanism was lost. A lot of the old philosophy simply wasn't passed on. German republicanism now means no federal intervention, no government spending. Unfortunately, to many people, it just means saying 'no' to everything. Freethinking, and people going out to crusade for things, just vanished. When you're outnumbered you keep your mouth shut. If we did go back to some of that old philosophy, we'd be totally out of step with the Republican party now."

In democratic societies, a fearful price is often paid by people who are regarded as politically irrelevant. The stance of Hill Country Germans from the early 1850s through Reconstruction marked

the high point of their assertion in American political life. Under increasing cultural and ideological pressure, the Germans slowly, and at first imperceptibly, began to retreat—to withdraw into themselves. The 1914–18 era of wartime propaganda hastened the withdrawal. For seven decades, German language and music had flourished in Texas, and German newspapers had prospered in a dozen towns. German language was routinely taught in the schools. But during World War I, Texas lawmakers saw to it that German language instruction ceased in the public schools. Even on the streets of Fredericksburg, Germans heard themselves called "damned Dutchmen." Church services in German diminished, and by the end of the 1940s most regional newspapers had stopped publishing German editions. German was still spoken in many homes, but outwardly the signs of German culture were disappearing. People moved out of their old stone farmhouses into new brick ranch houses, and the aura of Germanness that once pervaded towns like Fredericksburg faded somewhat.

Or so it seemed. But efforts to Anglicize the German Hill Country couldn't do away with the work of the past. The early German settlers had built well. The old stone buildings didn't crumble; the stone fences still stood.

Today, the Anglo town of Johnson City, despite a certain sprucing from federal funds spent on the LBJ Ranch during the Johnson presidency, remains a random assortment of battered wooden stores and frame houses. Only thirty miles away, Fredericksburg seems—as it has always seemed—solid, purposeful, and "prosperous." Germans of the eighth generation can now look down its main street and know there is no other market town in Texas like it, the whole of the main street—the widest in Texas—flanked end to end with stone structures. The hills are stony and often brown and the cedar brakes are everywhere, but Hill Country Germans have survived beyond the wildest dreams of Solms-Braunfels and his Adelsverein partners. In William Faulkner's phrase, they have "not only endured, they have prevailed."

The German experience in the Hill Country is now approaching a full century and a half. At the heart of this experience are values which seem contradictory: a strong sense of community and a deep belief in self-reliance. Both values are actually integral parts of a powerful nineteenth-century tradition which sought to define a "just society" by careful preservation of individual freedom through cooperative action. It was a system of values which had as its cornerstone the belief that just rewards for hard work and individual achievement would develop best in the framework of a cooperating

community of citizens consciously established to protect its participants against organized exploitation and oppression. Such a society demonstrated its respect for human beings and nature by protecting the central ingredient of a self-governing commonwealth: free labor on the land. The threats to free labor were understood to be speculators, land syndicates, standing armies, and banks.

The German platform of 1854 was instantly controversial because of its antislavery clauses, but the manifesto was actually much more—a far-ranging document that spelled out broad safeguards to protect the rights of farmers and artisans against systematic distortion of democracy by those economic and governmental elites. Its preamble praised the U.S. Constitution as "the best now extant" but lamented the fact that both major parties were not dedicated enough to advancing democratic values.

The Hill Country pioneers thought that democracy could be achieved only by a consciously organized, free association of citizens—a democratic community. The creation of such a community was seen as the primary purpose of politics and public life; it was this sequence of individual and civic duties that framed the public outlook of Hill Country Germans.

The values of self-reliance that formed the basis for these political beliefs became deeply rooted in Hill Country culture and the way people behaved with one another. In the ethical world of German artisans, proper labor demonstrated itself not only in hard work but also in skill. Not only were tasks performed on time, but one did them "right." Whether while repairing a wagon or building a stone fence, sloppiness in craft constituted nothing less than a breach of values that weakened the cultural bonds linking people to one another, to their community, and to their shared heritage. In the hierarchy of sins, pretense ranked almost as high as irresponsibility in work. Ostentatious display contradicted egalitarian values. Even when Hill Country families attained some real prosperity, it was not considered seemly—by them or their less affluent neighbors—to show it. As one Hill Country farmer summed up: "There were people who thought of themselves as 'so fine,' but they were treated like the rest of us. We didn't have much class distinction. There wasn't a lot of money; people had land and property but not a lot of cash. People from all walks of life worked together."

But today, the German Hill Country faces a new kind of assault. There is something in the American past that people want to recover. There is a sense that this "something" can be found on the Edwards Plateau. The stone buildings give a feeling of solidity and permanence that seems to provide an enduring connection with the past. Among the dry arroyos and limestone outcrops, among the stone

fences that German farmers built, Texans strive to reconnect, to rediscover their roots.

Coincident with the rebirth of interest in ethnic history and the search for "roots" in the late 1960s and 1970s, urban wealth began to move out of Dallas and Houston, Austin and San Antonio into the Hill Country. The things that had made life so difficult for so long turned out to be the very things that, in preserving the land, have made it so attractive to outsiders.

The irony is striking: urban Texans with a long Anglo heritage now flock to the Edwards Plateau to be around something authentically their own, something forthright and western. Even the "different-ness" of the Germans themselves has become a source of admiration. It is an admiration wholly undisguised; people are ready to pay huge sums of money to express it. Land values have soared to a degree that would have transported the original Adelsverein promoters. Hill Country people are finally getting rich.

But the new prosperity has a price. In the 1970s, as wealthy newcomers began to buy the Edwards Plateau and preserve it, they began to appropriate it and, inevitably, to define it. The preservation of culture no longer serves merely psychic needs, but commercial ones as well. Culture, too, has become a commodity—one that fashions its own celebrations and festivals, commemorating and creating history. The past becomes the object of a new kind of speculation.

Hill Country Germans are both the beneficiaries and the victims of this new turn of events. Their towns are awash in new wealth, new jobs have proliferated, old buildings are being preserved, and their history is being "honored." But the honoring is curiously defined in ways that often seem quite inappropriate and oddly misplaced. Public life emerges as a kind of entertainment ritual, with bands, balloons, costumes, and flags, but with little context or substance. The view of the past, while commercially entertaining, has little connection with what actually happened. What is at work here is the trivialization of public memory and public life. In the process, a society runs the risk of losing the sense of its own history as a commonweal, and eventually a sense of its own values.

To many hard-working Germans, what is taking place in the Hill Country seems out of proportion to the real value of things. People search for ways to describe their unease. As a respected Fredericksburg gunsmith tries to account for the situation:

Some of us when we look around at what is happening, we feel we are losing ourselves.

Outsiders are taking over. It's not all bad; they are good people by and large, and they help protect our buildings, and bring money to the community, but the values are all different now. We used to be a town that didn't believe in easy money. There was a sense that an "honest day's work" got an "honest day's wages" and things had real value. I can't tell you exactly what that means, but I know it doesn't mean one more antique store selling what we used to live with.

A younger lawyer puts it this way: "There is beginning to be a class system now, conspicuous consumption and fancy tuxedo benefits. I hear complaints about commercialism and how expensive things are getting."

Though the details are unclear, an uneasy feeling lurks that somewhere a connecting thread to history has been lost. The memory of pioneer struggle is very much alive, but there is uncertainty about the meaning of the struggle of parents, grandparents, great-grandparents, and, indeed, all the eight generations who have lived on the land once called Comanchería. People don't feel entirely comfortable about how to react to the memories of sacrifice and hardship and poverty that characterized much of this struggle. In short, there is uncertainty about how to remember and what to remember.

A fundamental American dilemma defines itself in the Hill Country today—a kind of dislocation, a confusion about the meaning of the past and our connection to it. This kind of dislocation is not a problem merely for the Germans of the Hill Country but for millions of contemporary Americans as well. It is a problem that many urban newcomers to the Hill Country are trying to escape. With this sense of dislocation comes its corollary, a sense of longing. Country-western musicians write about it too. Near the Hill Country, Willie Nelson writes about faded Texas villages where old men in their twilight years puzzle through the meaning of their lives, lingering, in Nelson's words, "like desperadoes waiting for a train." The uses of the Western legend have worn thin. An urgent uneasiness is exposed. It is a feeling that is not restricted to old men in dying backwater towns.

As people search for reconnections on the Edwards Plateau, there is something in the German frontier struggle that does shine through. The Germans of the Texas Hill Country created a mode of living that was a powerful expression of nineteenth-century American striving. Self-reliance was more than an attribute of self; it was part of society's belief in the value of work and the interrelatedness of

individual effort to the collective vitality of the community. This blend of individual self-respect and collective self-confidence—this vision of the citizen commonwealth—gave shape to the past and meaning to daily life. It is this vision that is obscured in commercialized civic ritual.

The story of the German struggle in the Hill Country is finally neither triumphant nor tragic: it is ongoing. It offers more than a momentary insight into America's regional history. It expresses an essential dilemma of the nation's political heritage and the continuing struggle for a truly democratic society. This heritage is a treasury that can be tapped at any time. But to do so it is necessary to avoid romanticizing the past. It then becomes possible to come to terms with its meaning.

3.

Continuities, 1971–78

. . . and the people endured into our own time.

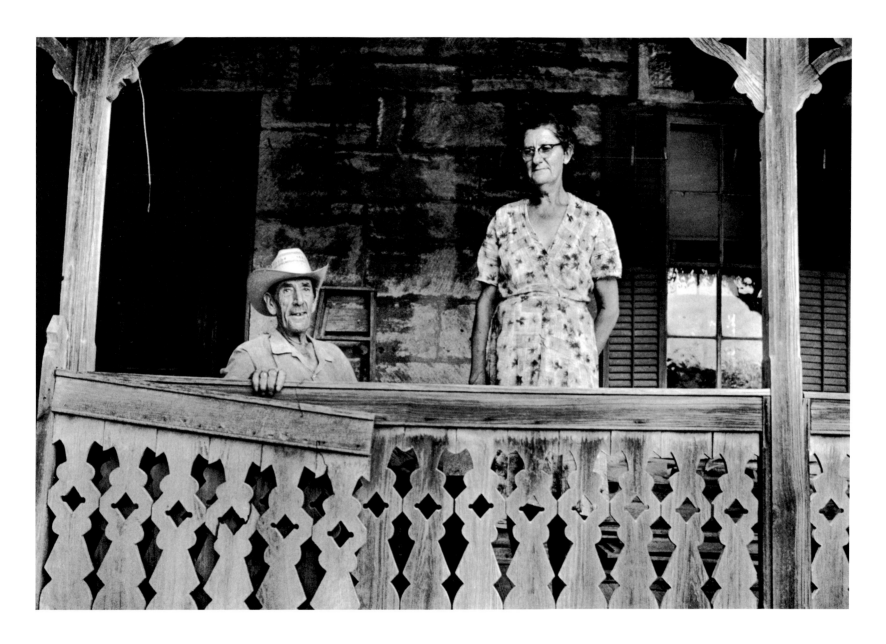

The third generation, Grapetown

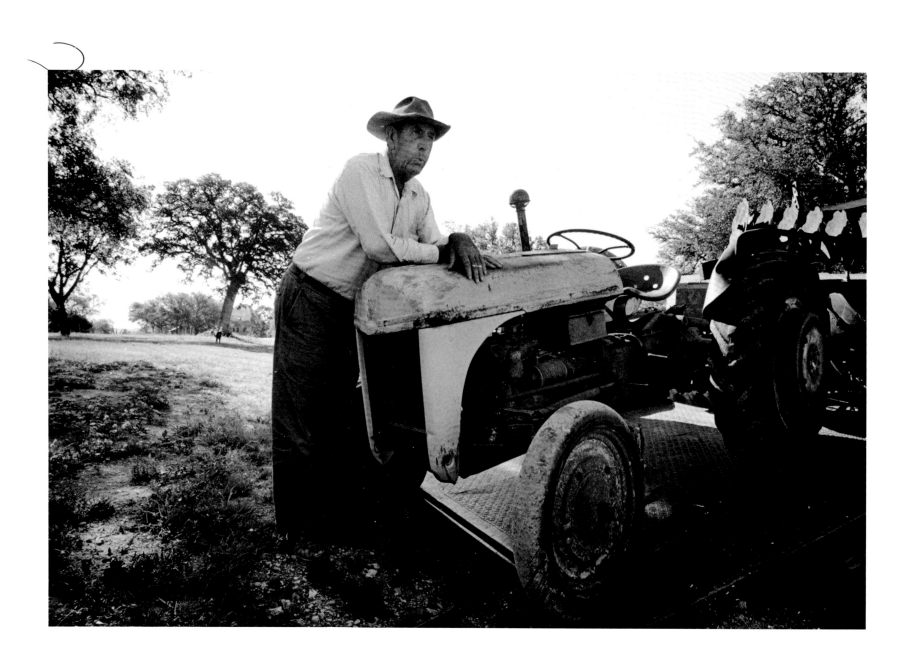

Edwin Rausch, Grapetown

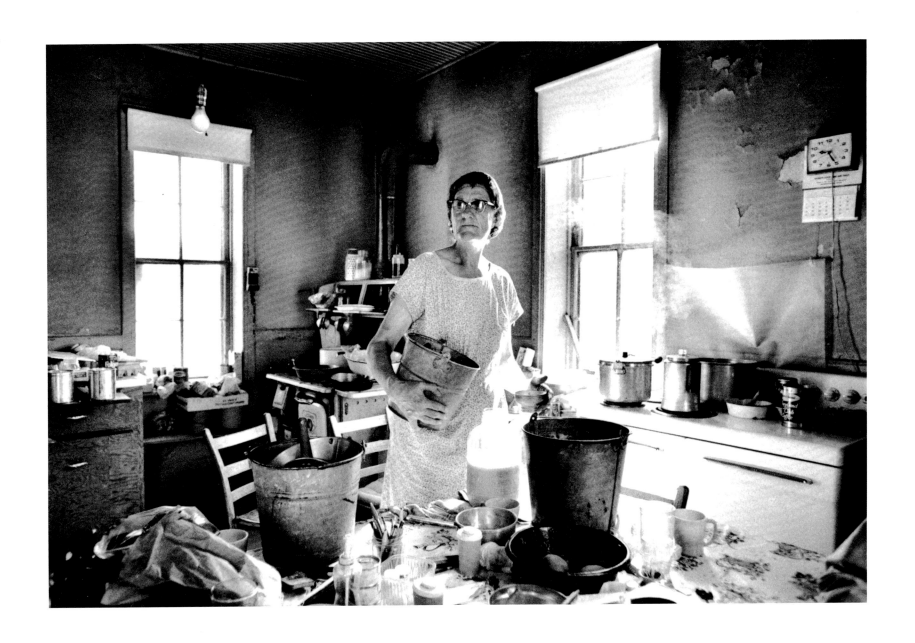

Paula Rausch making *kochkäse*

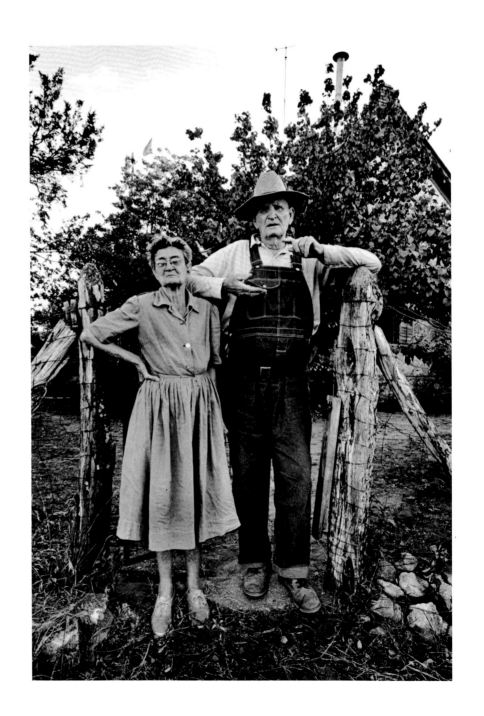

Mr. and Mrs. William J. Frantzen

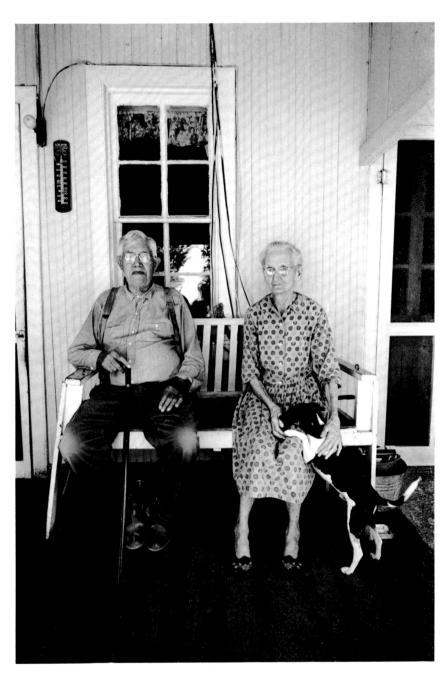

Mr. and Mrs. Carl Reinhard Frantzen

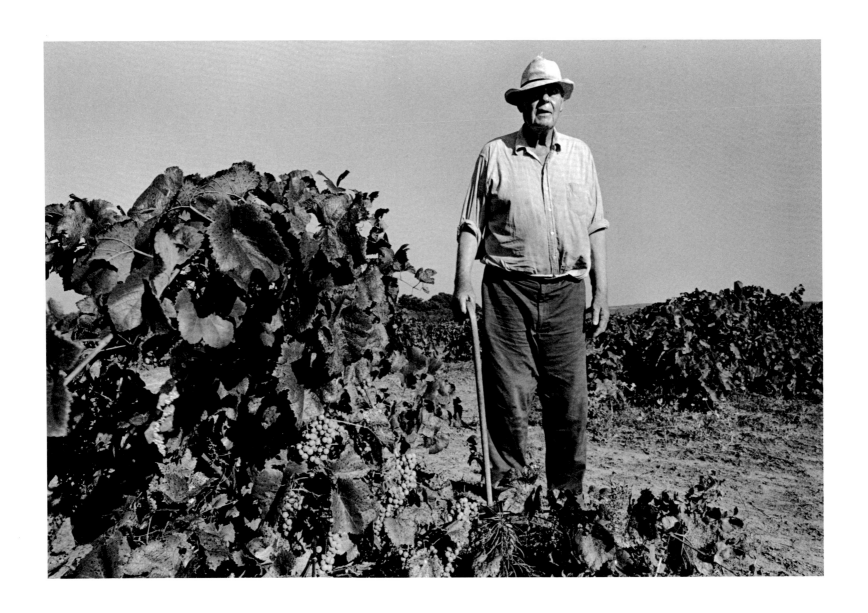

Emil Eberle

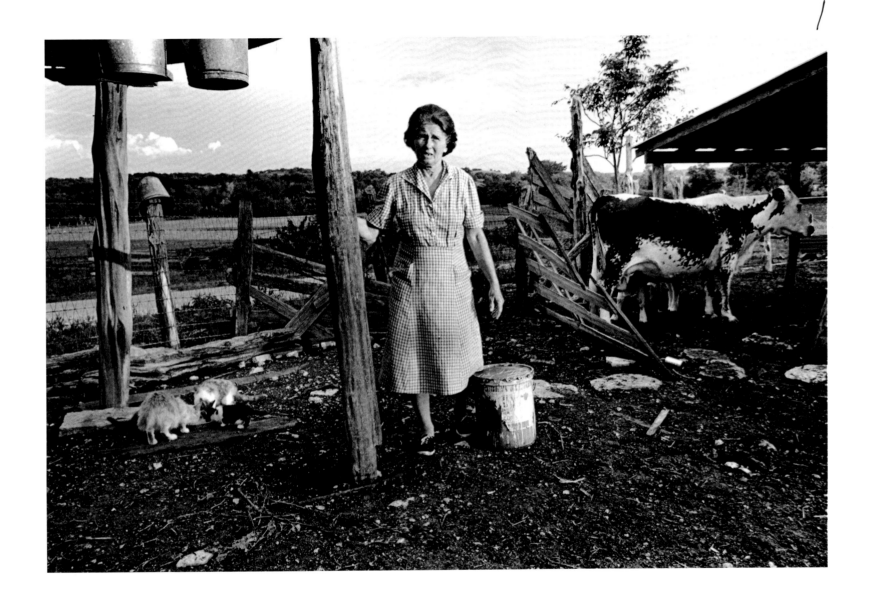

Clara Luckenbach

49

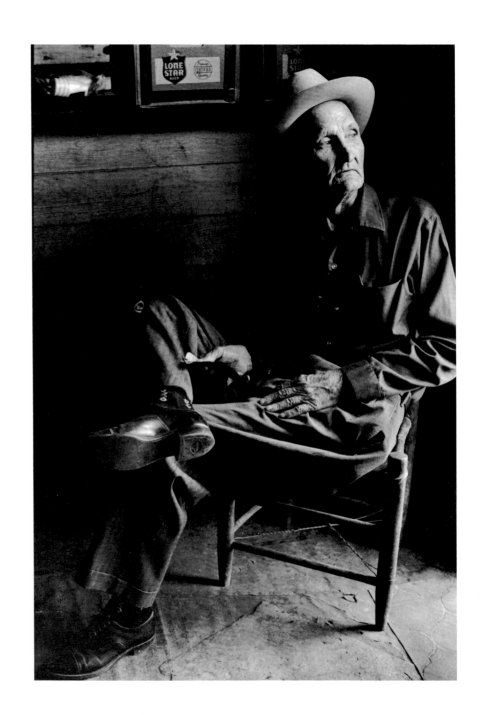

Alfred Frantzen at Luckenbach store

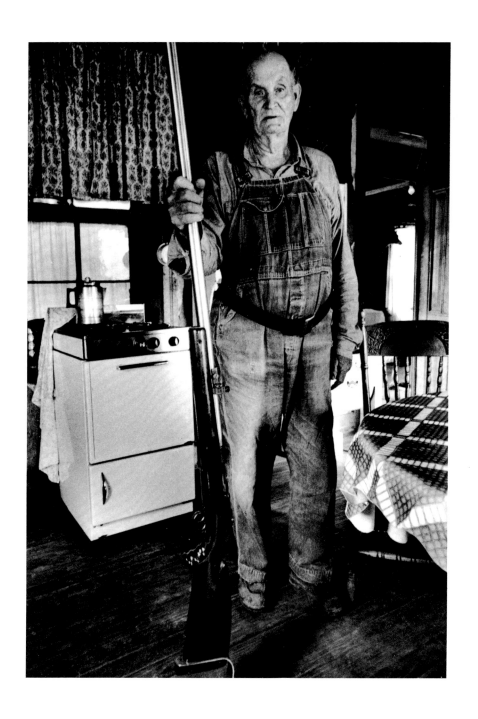

William Frantzen with his *schuetzen* target rifle

51

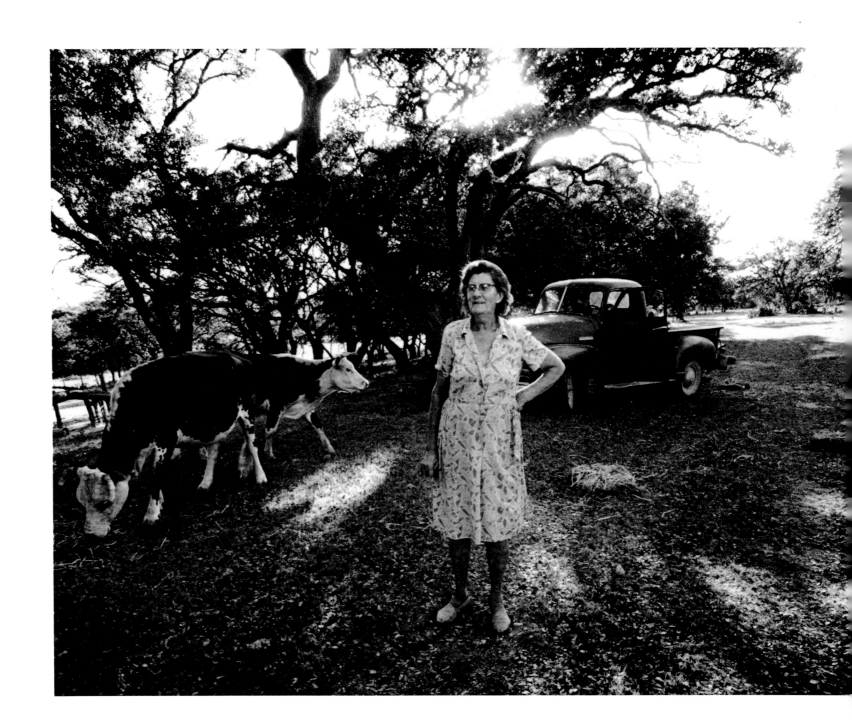

Paula Rausch feeding cattle

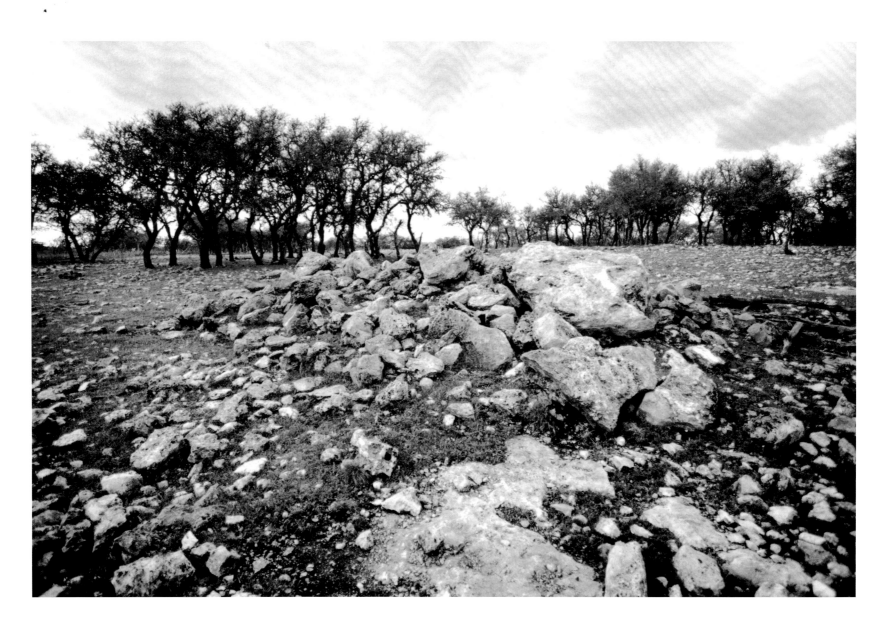

Off Pecan Creek Road, northern Gillespie County

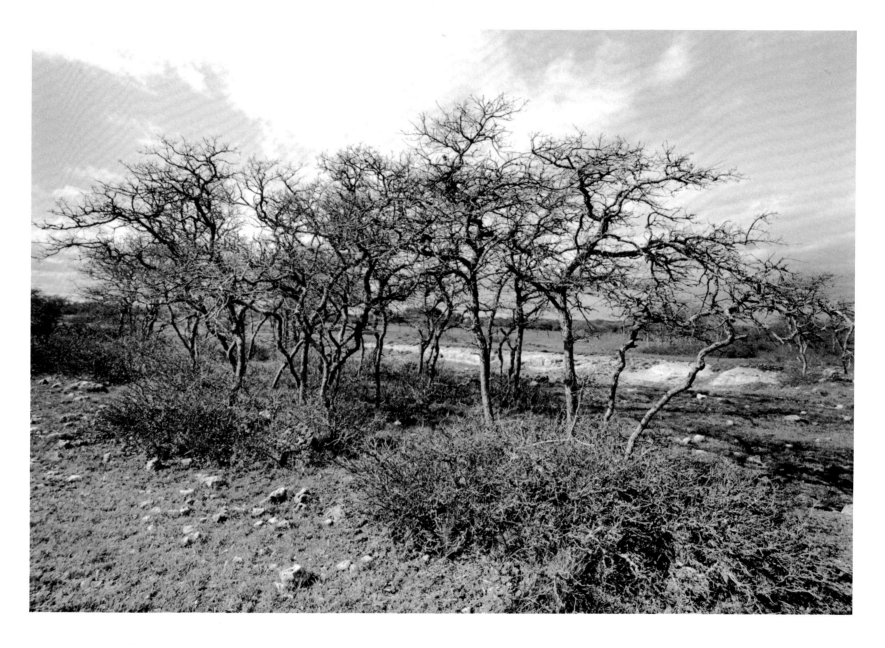

Off Crenwelge Road, northern Gillespie County

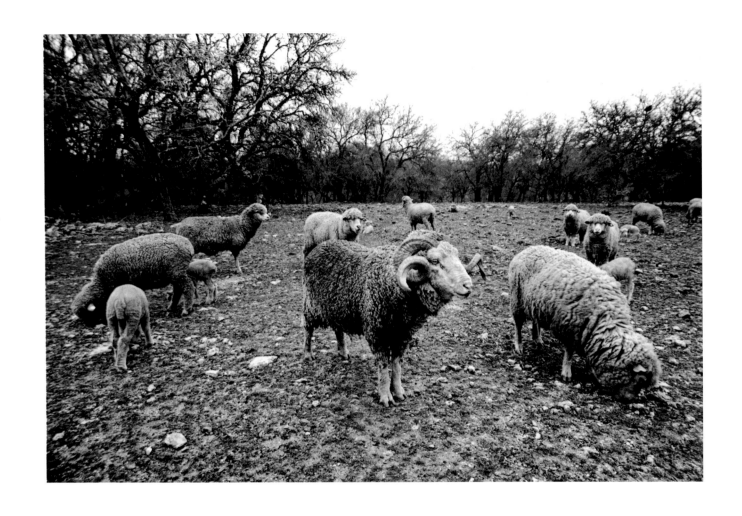

Merino sheep near Baron's Creek, Gillespie County

Near Spring Creek, northwestern Gillespie County

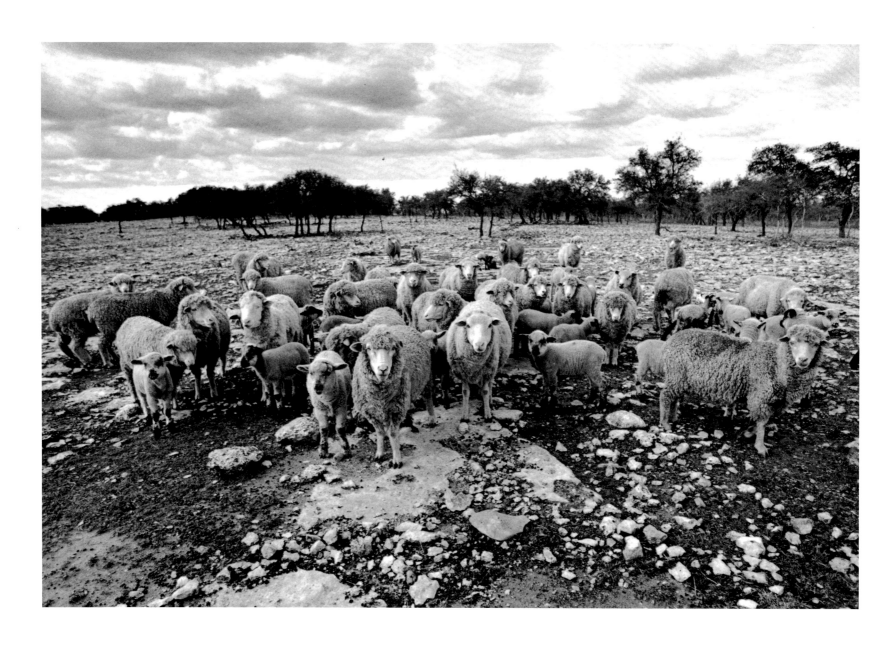

Merino sheep near Doss, northwestern Gillespie County

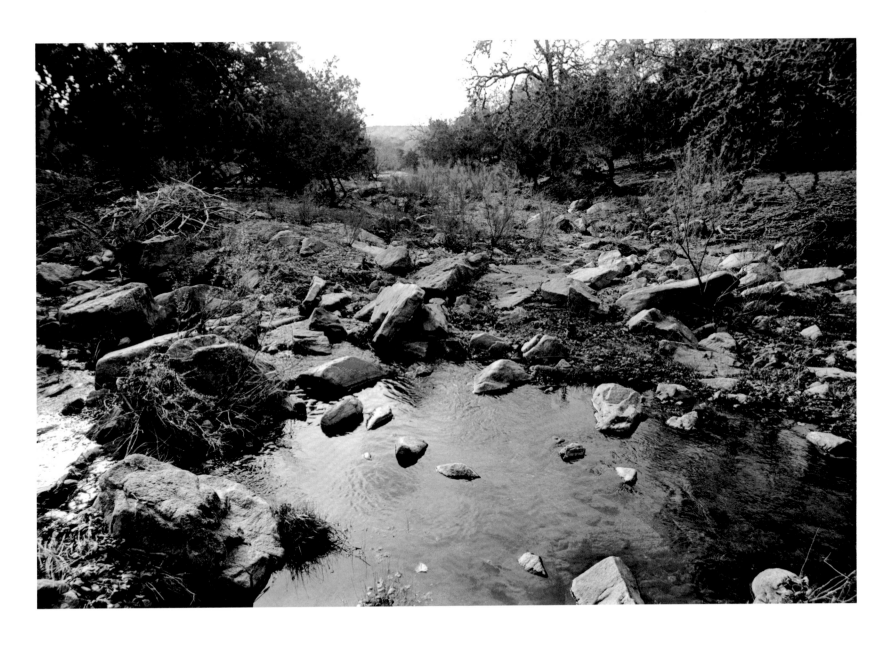

Branch of Bee Cave Creek, western Gillespie County

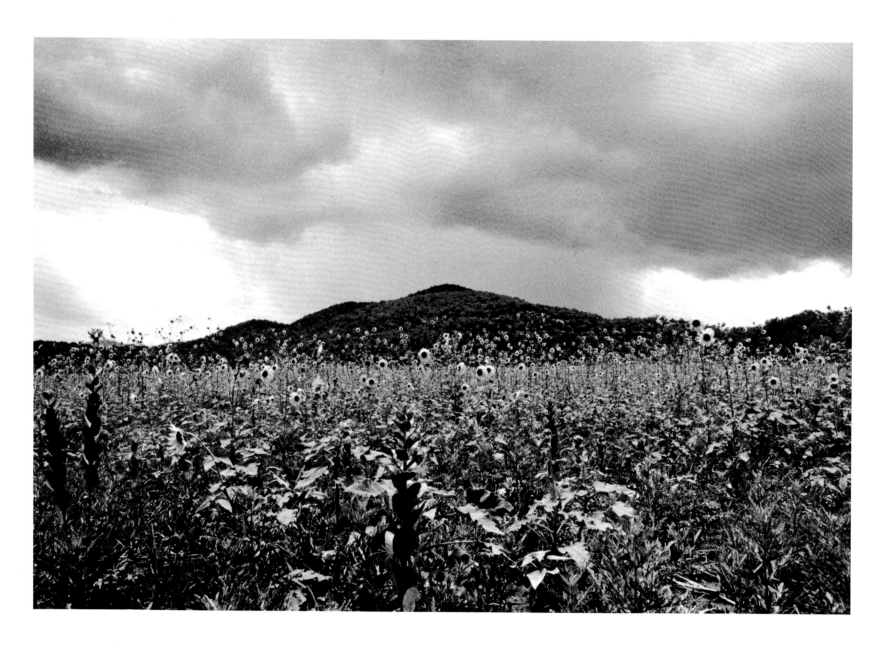

Summer shower and sunflowers, Kendall County

Luckenbach Catholic cemetery

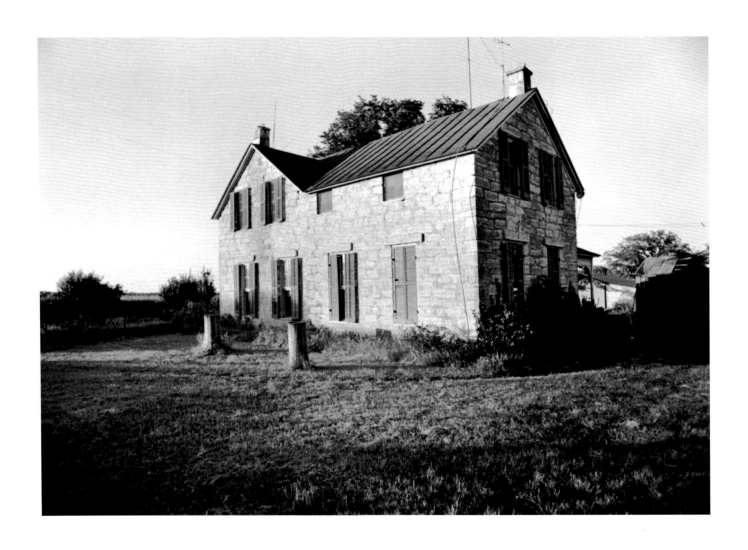

Luckenbach, Gillespie County

62

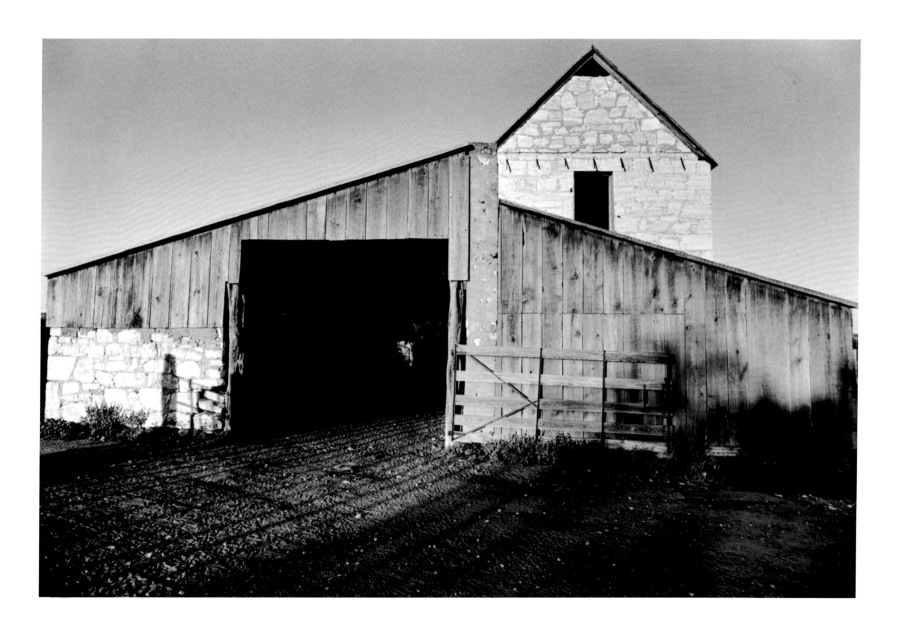

Cherry Spring, northern Gillespie County

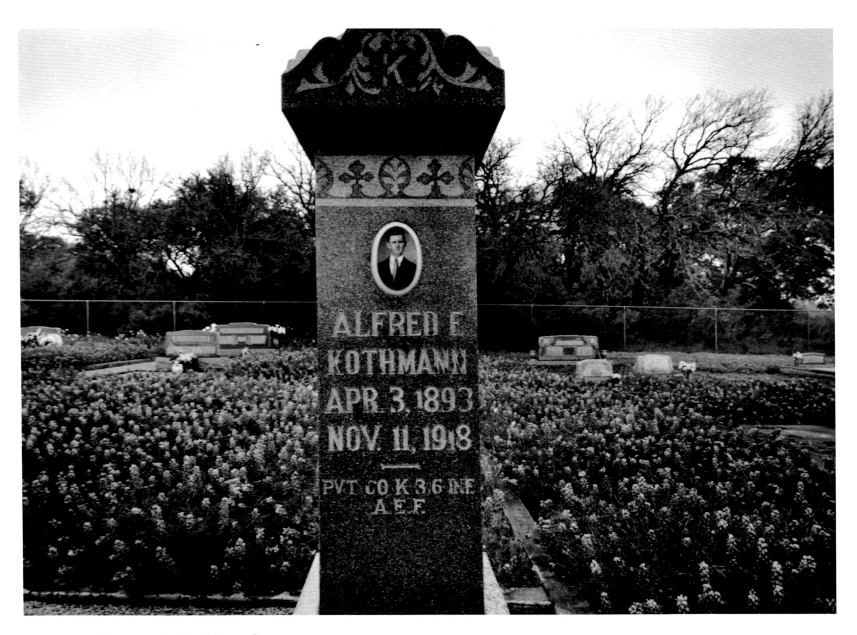

ALFRED E
KOTHMANN
APR 3, 1893
NOV. 11, 1918
—
PVT CO K 3 6 INF
A.E.F.

Cemetery, Hilda, Mason County

Angora goat and sheep ranching, Kendall County

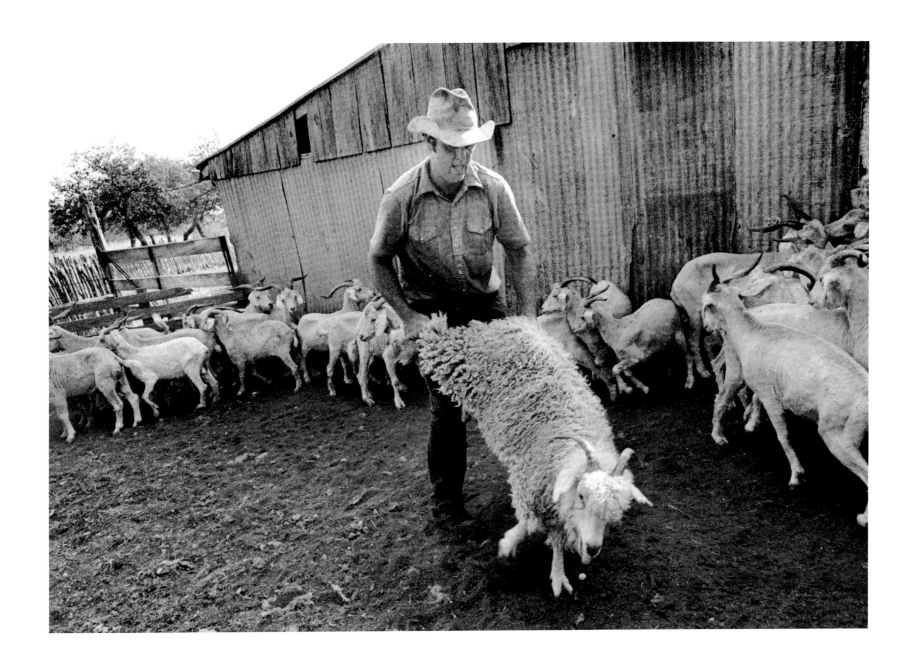

67

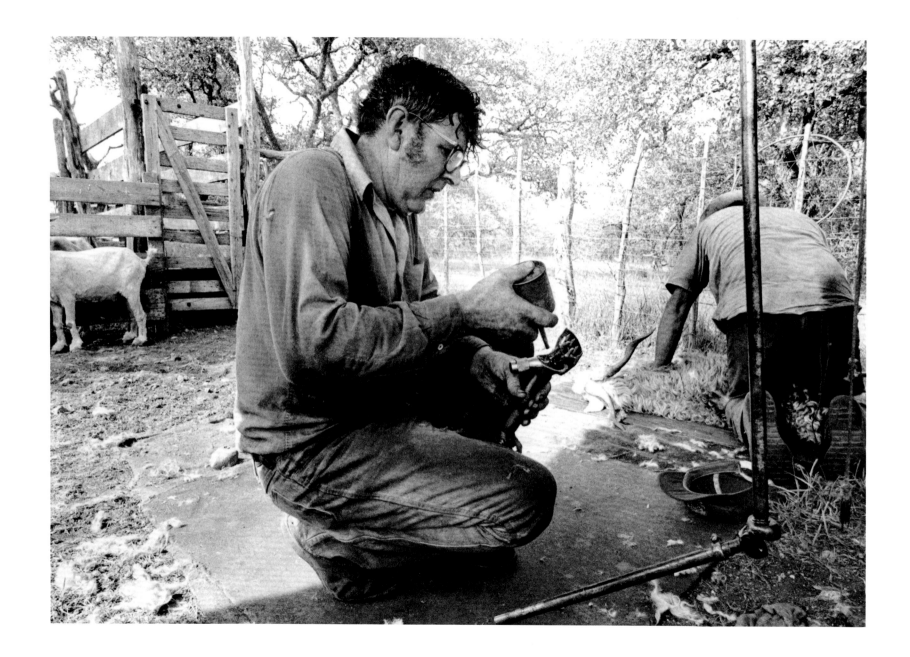

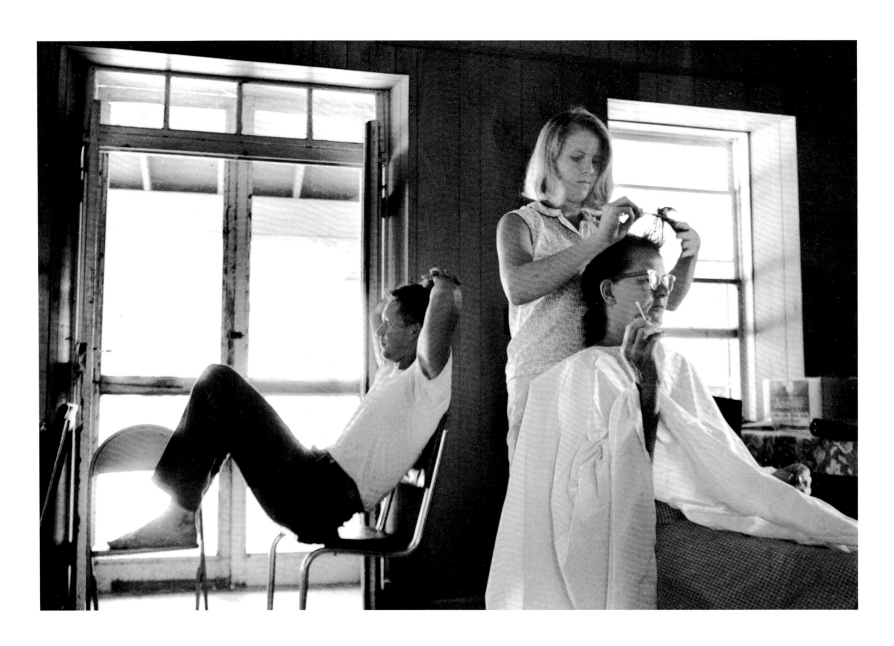

Joe and Anne Frantzen

70

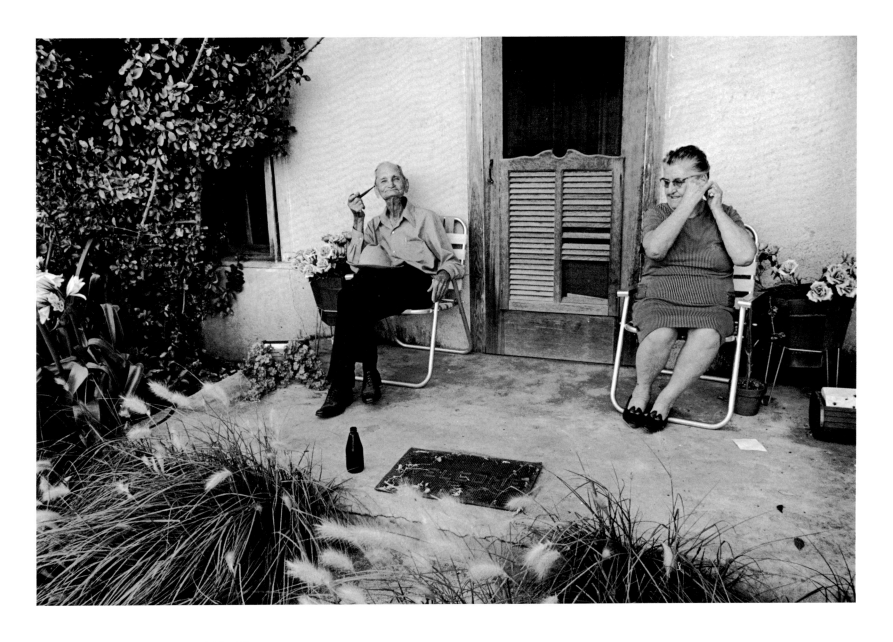

Mr. and Mrs. Alfred Frantzen

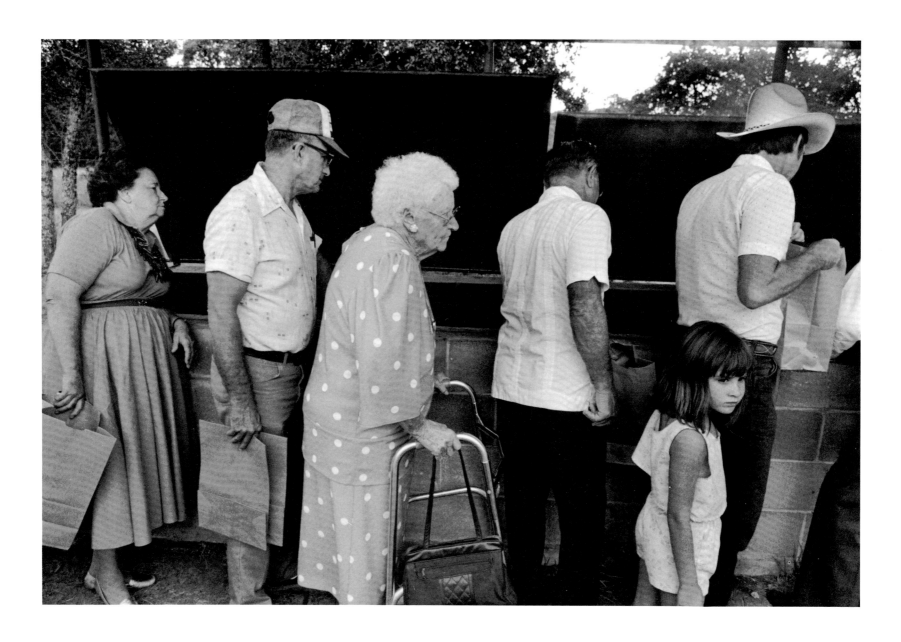

Teamsters reunion

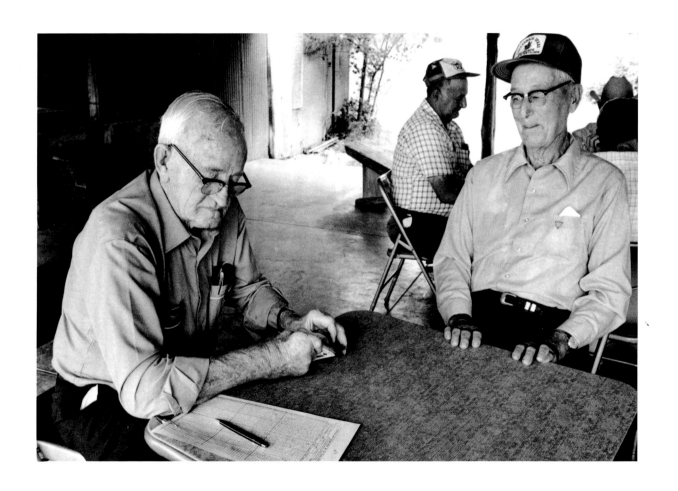

Skat card playing

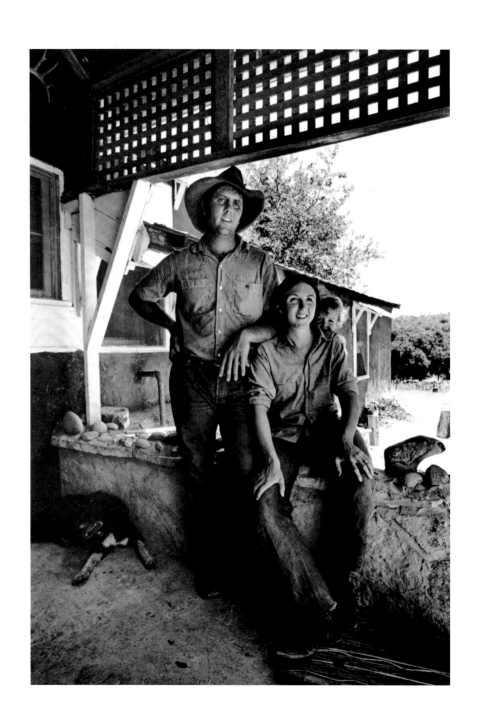

Robin and Vicki Giles, Kendall County

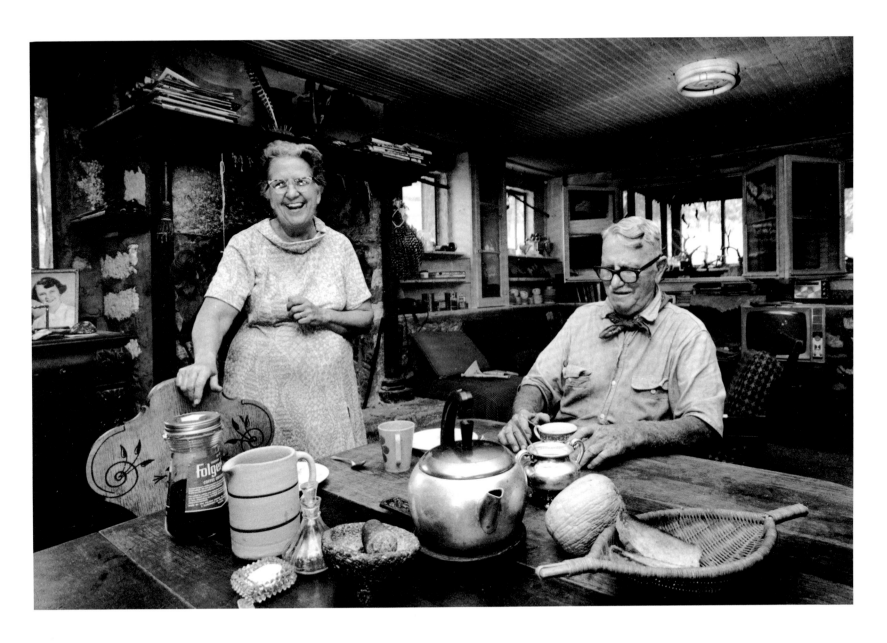

Palmer and Edie Giles, Kendall County

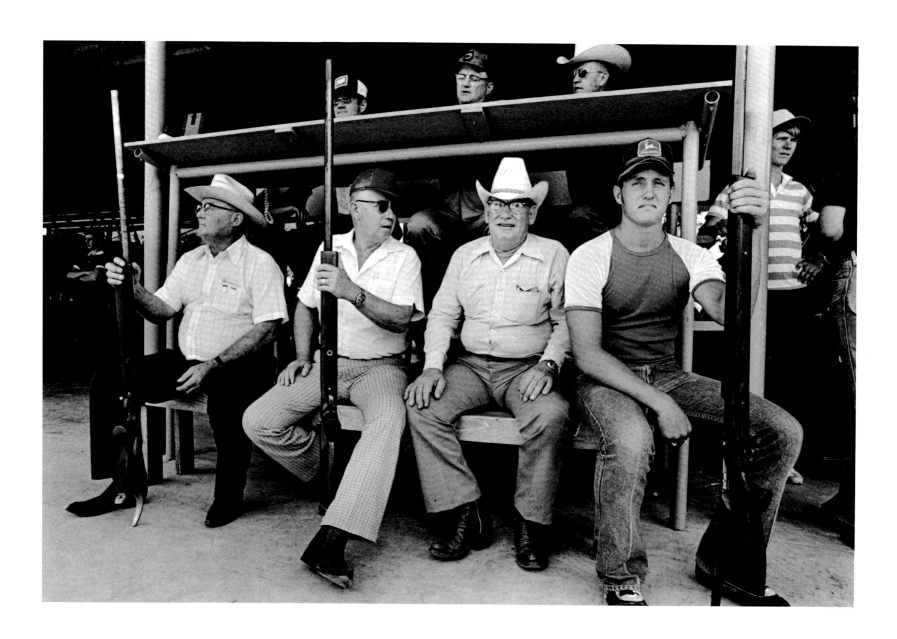

Schuetzenfest, shooting competitions

76

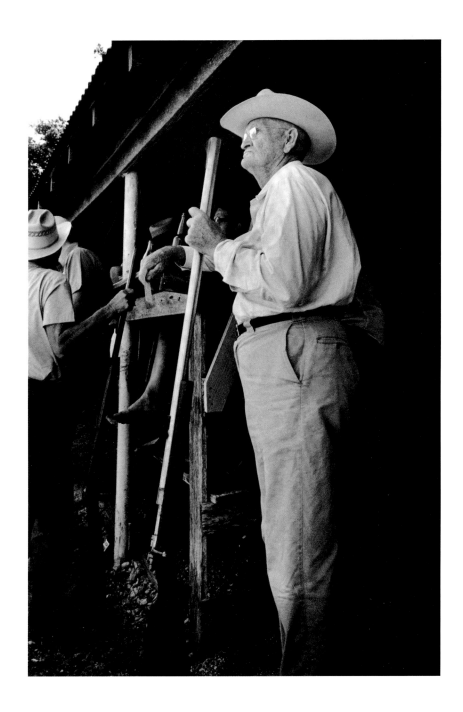

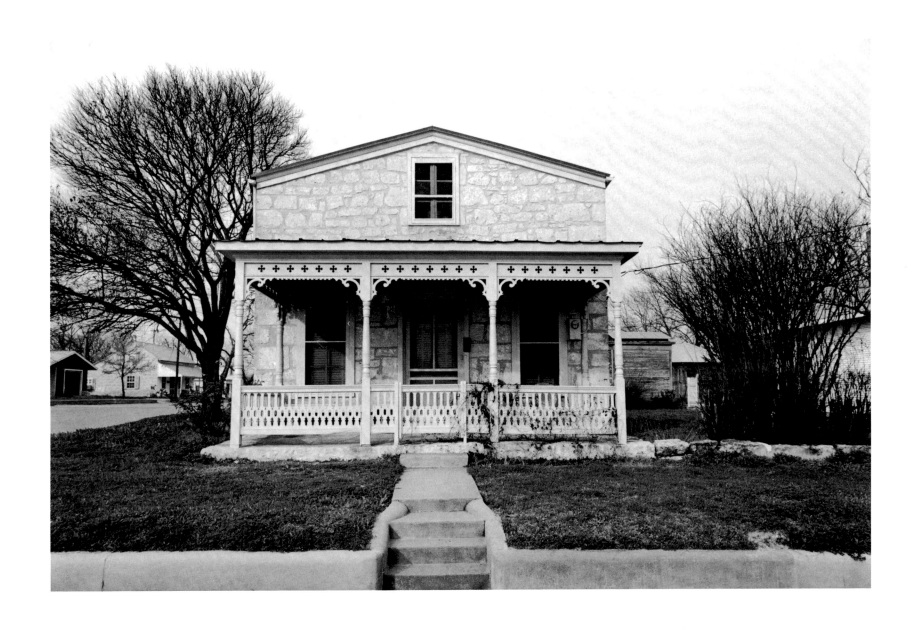

Fredericksburg. Limestone house

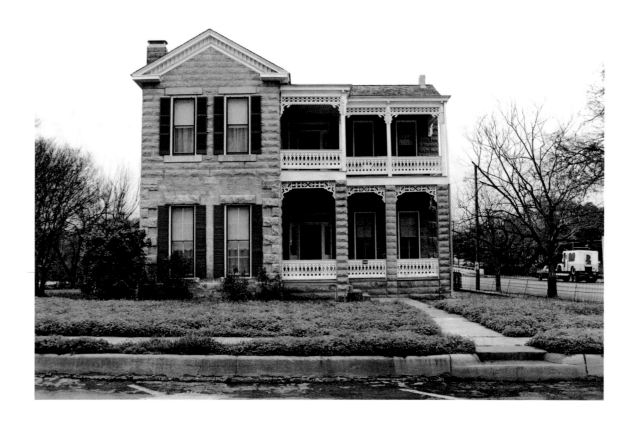

Fredericksburg. The Wilke home

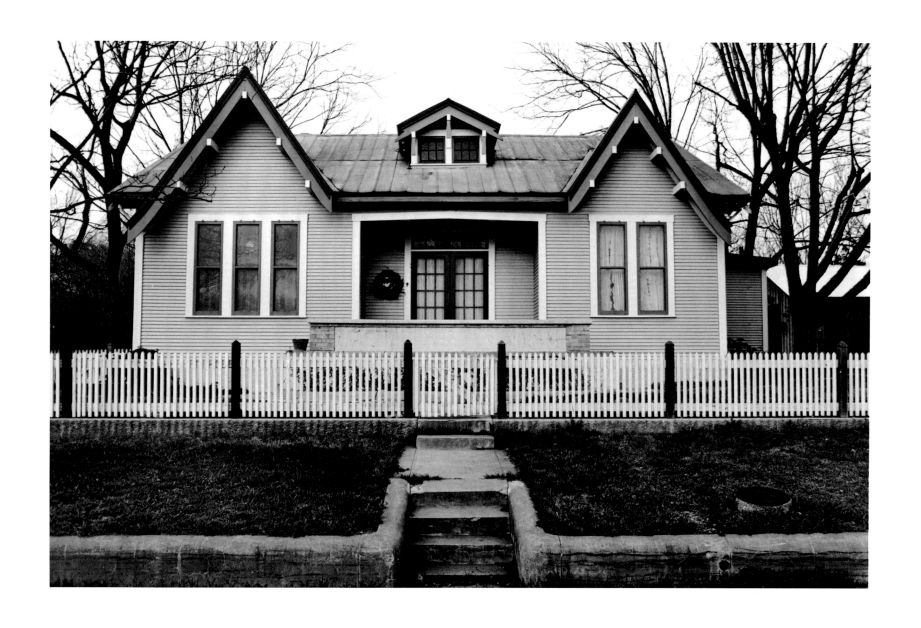

Fredericksburg. The Pedragon house

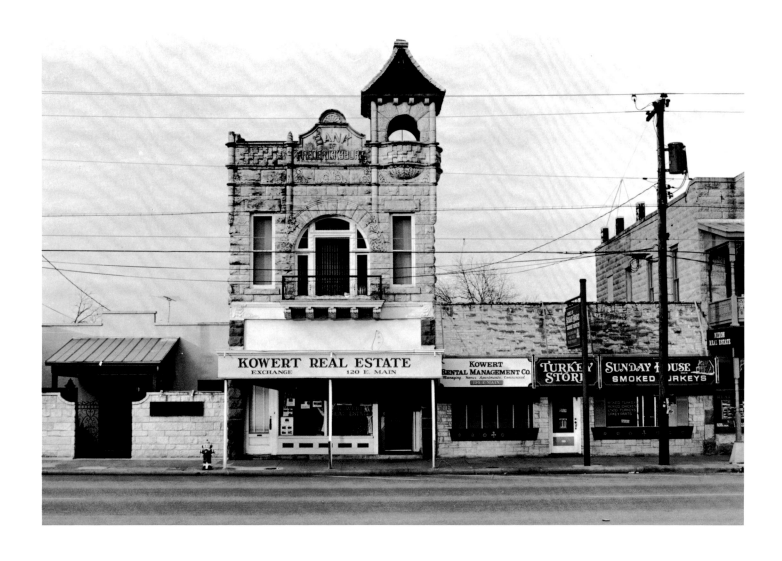

North side of Main Street, Fredericksburg

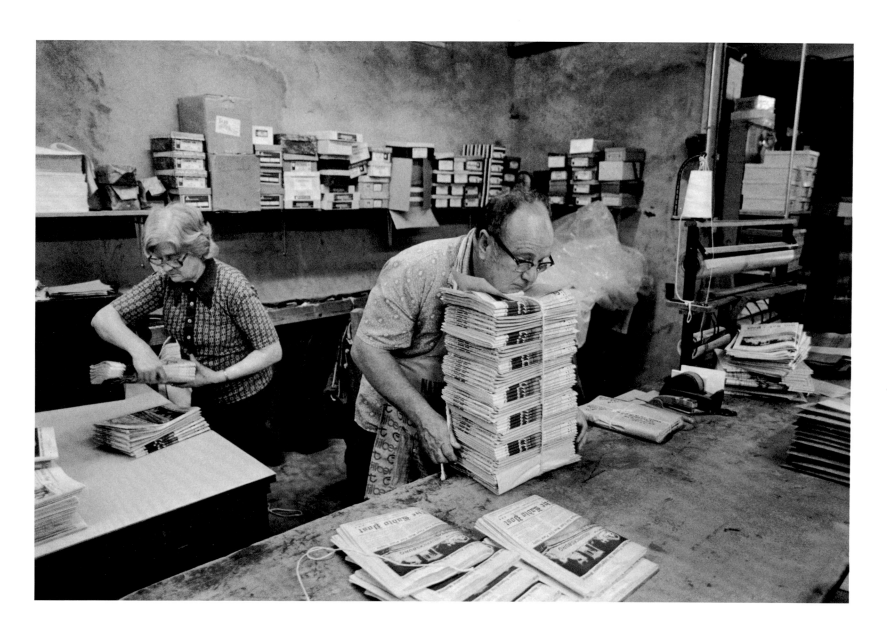

Fredericksburg Radio-Post newspaper

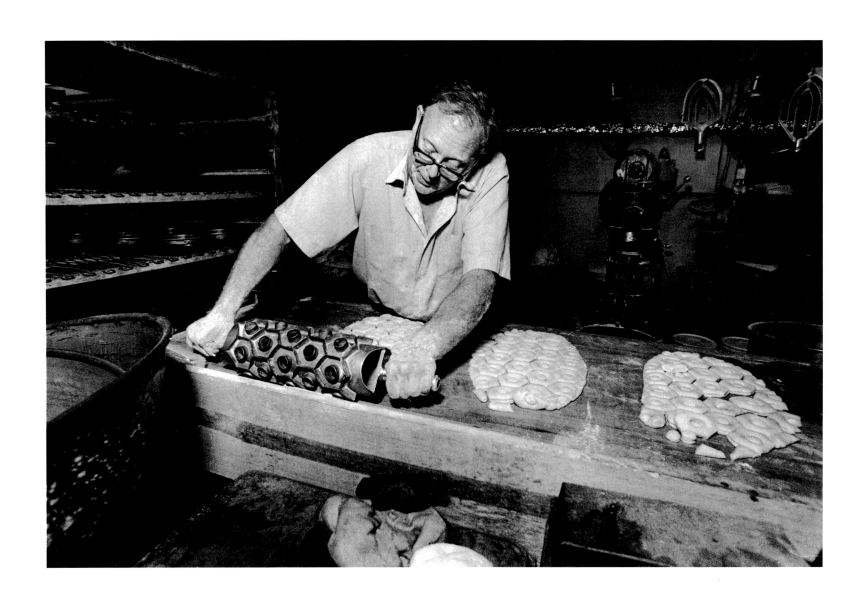

The Fredericksburg Bakery

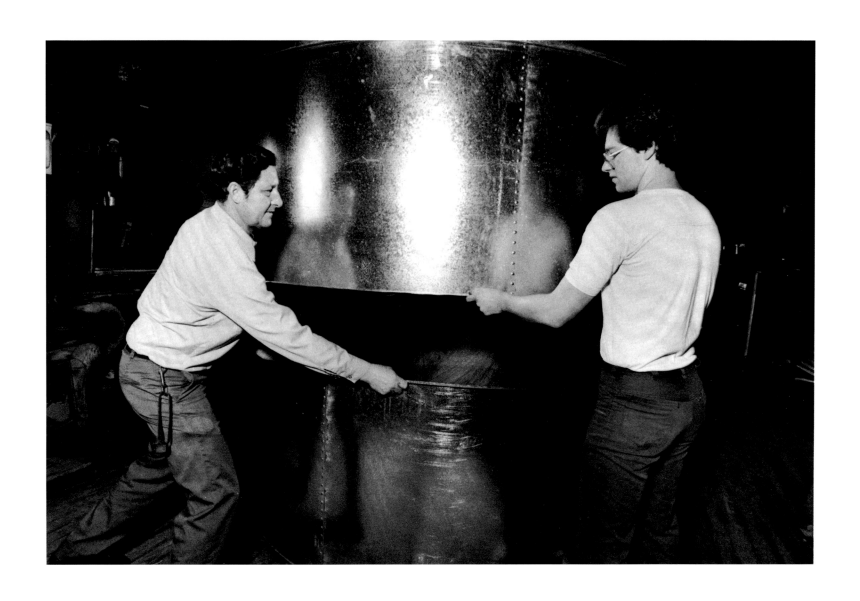

Two generations, father and son

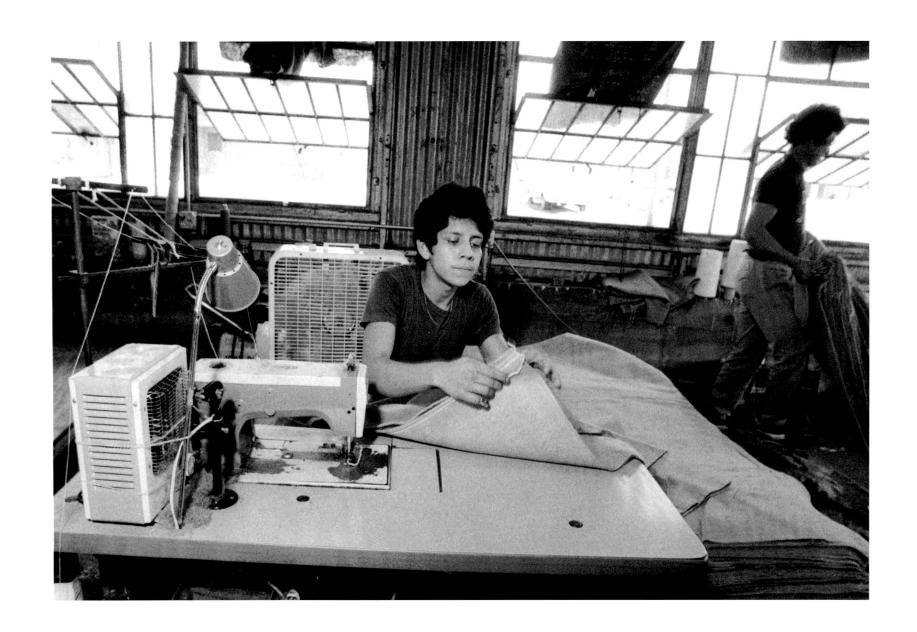

Wool Sacks, Inc.

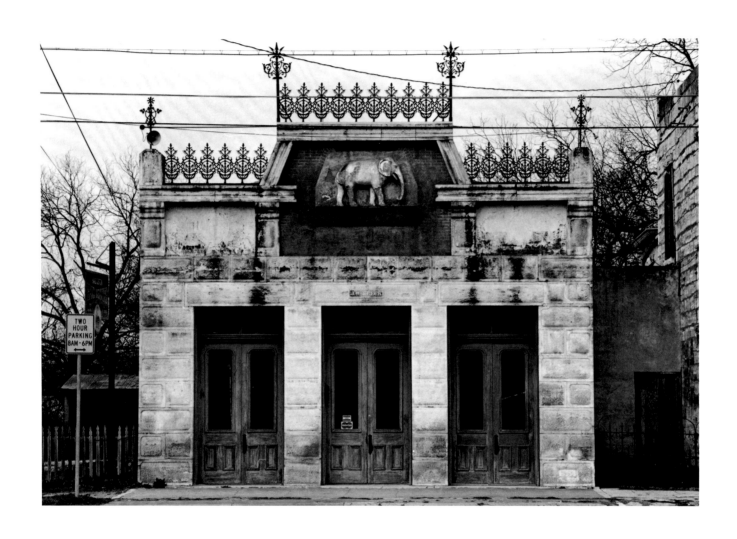

White Elephant Saloon, Fredericksburg

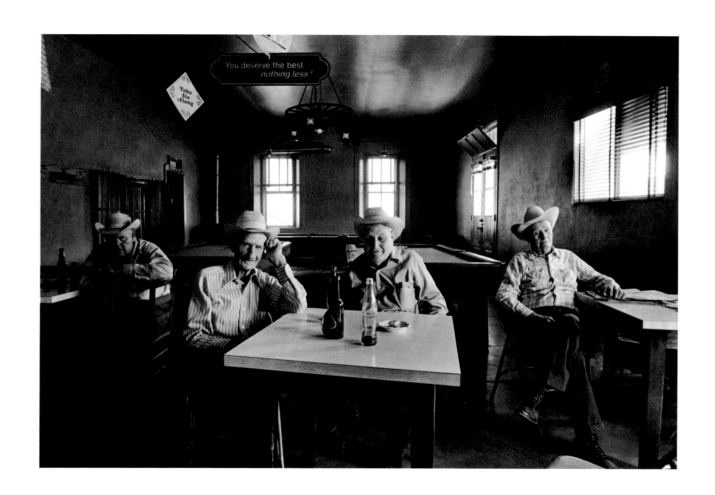

The Old Domino Hall, Fredericksburg

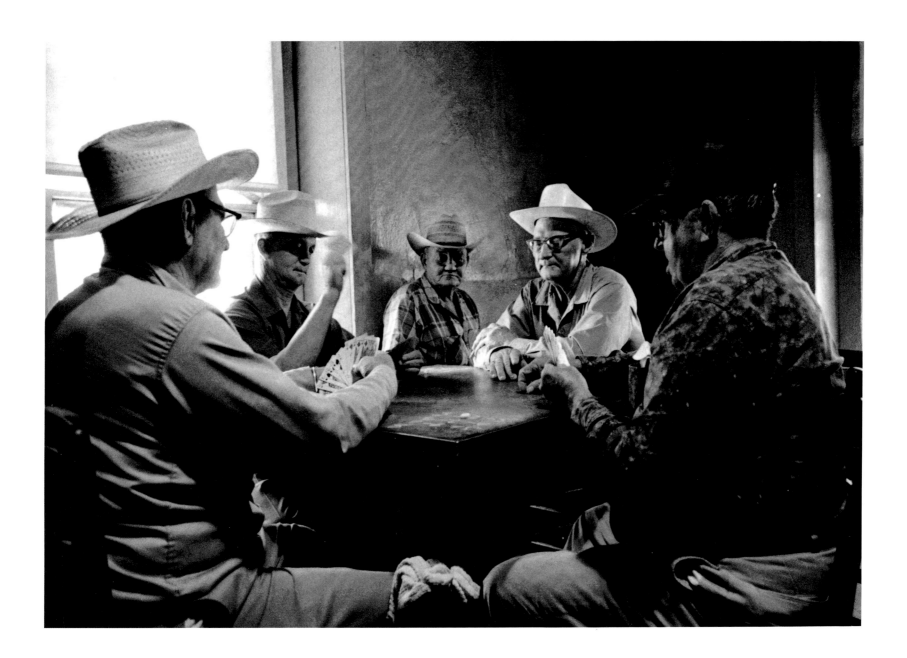

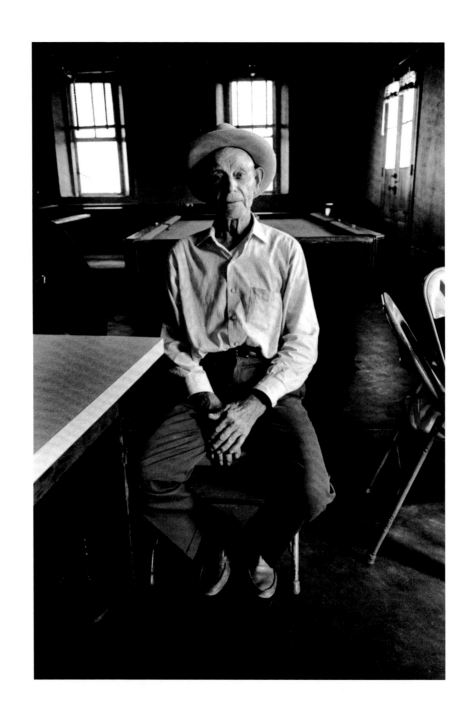

4.

Transitions, 1975–87

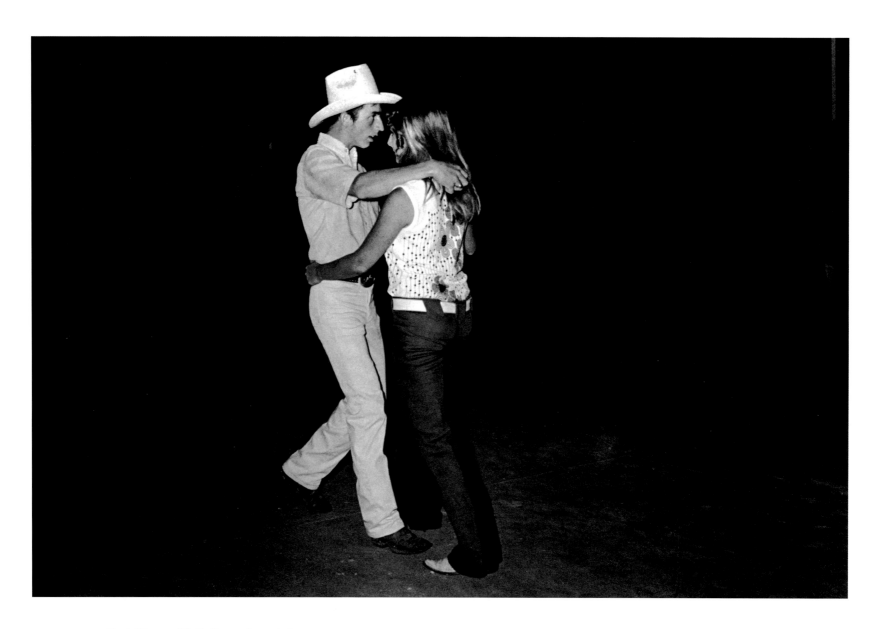

Pat's Dance Hall, Saturday night

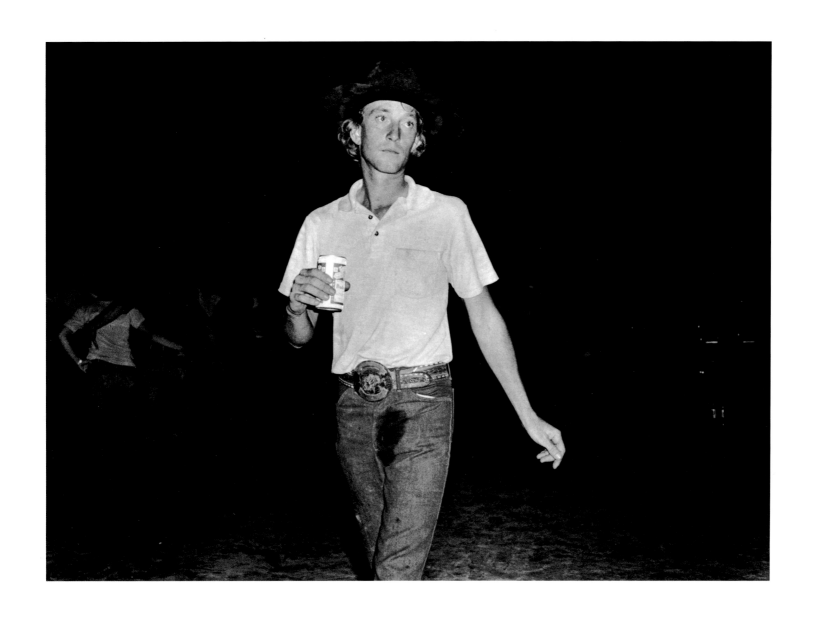

County Fairgrounds, Saturday night

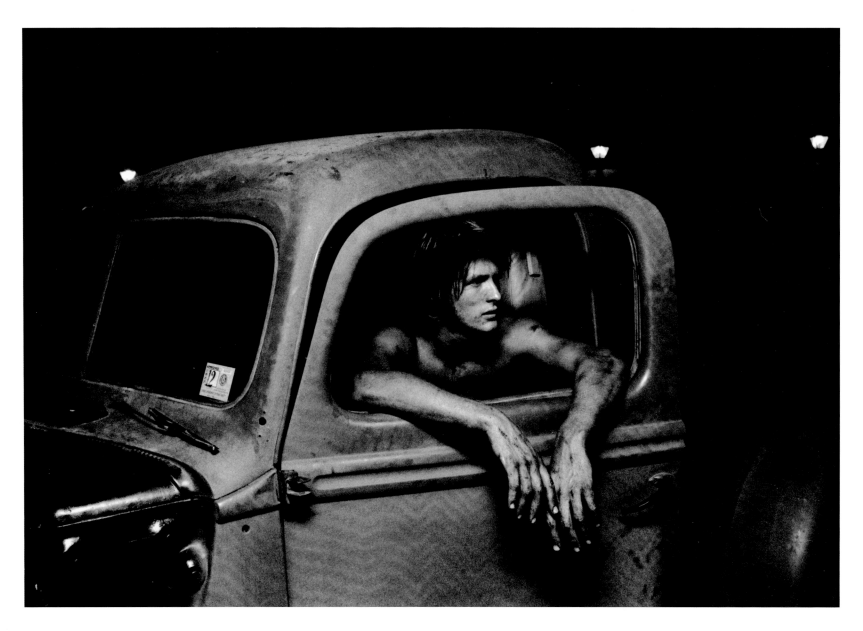

Sonic Drive-In, Friday night

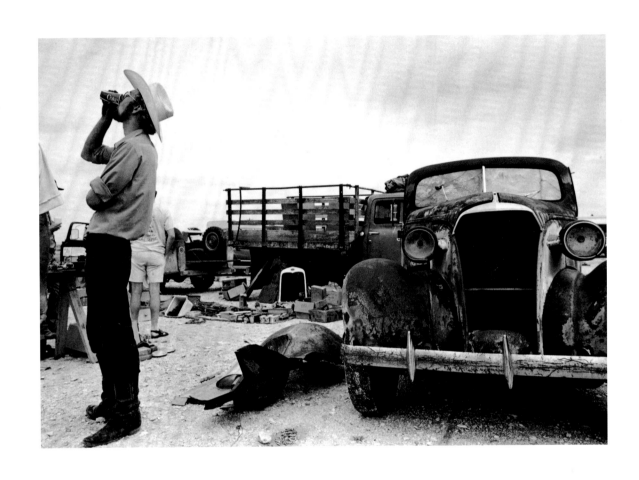

County Fairgrounds, antique car fair

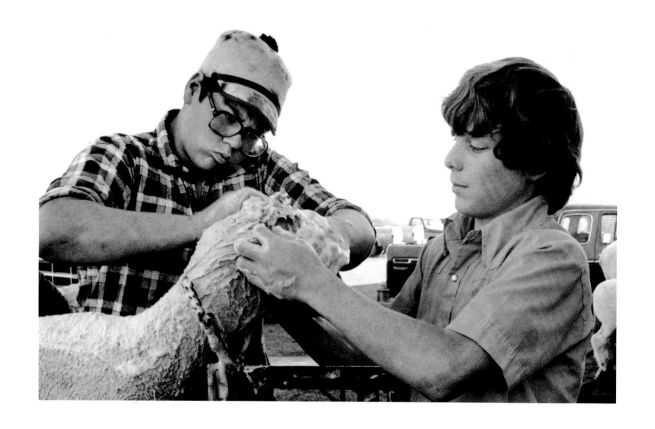

County Fairgrounds, Gillespie County Fair

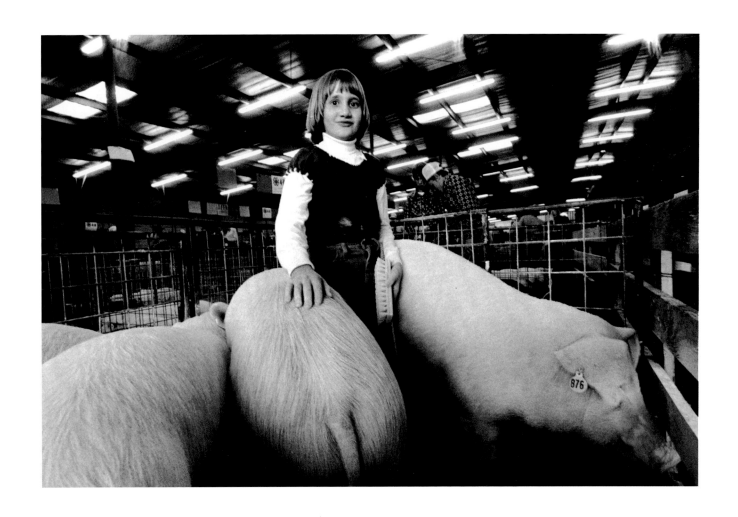

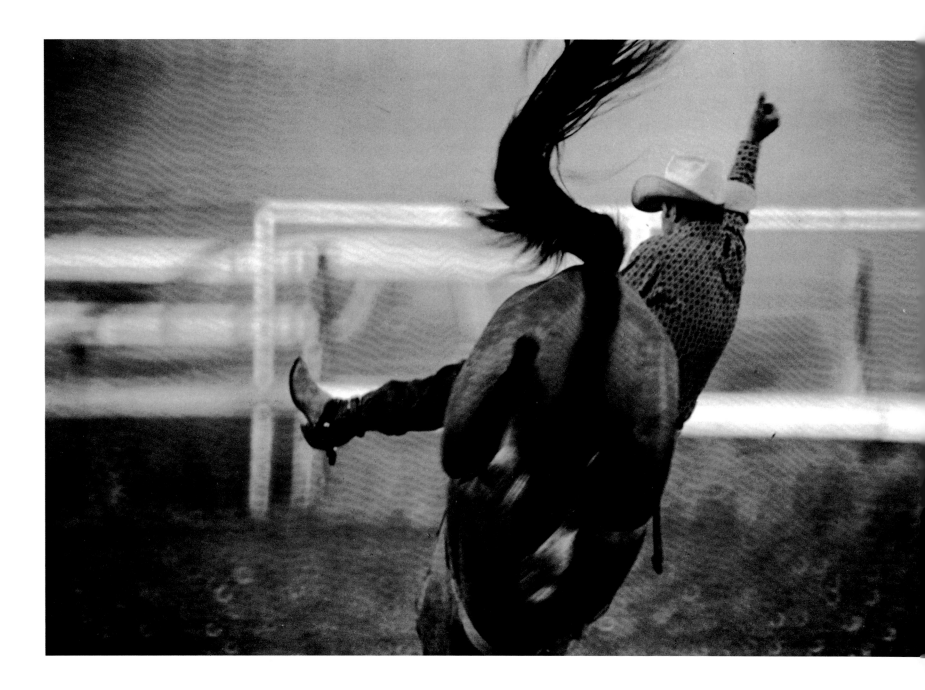

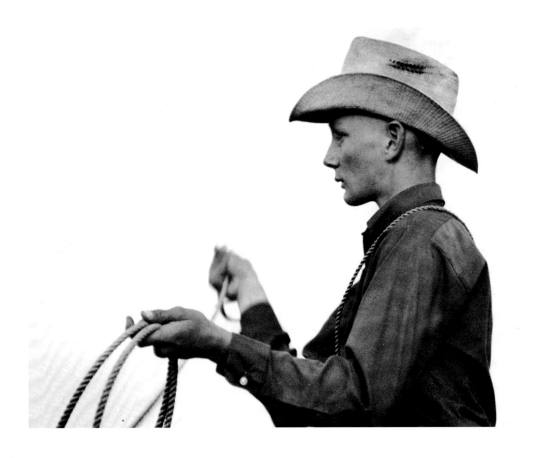

Rocksprings Rodeo, Edwards County

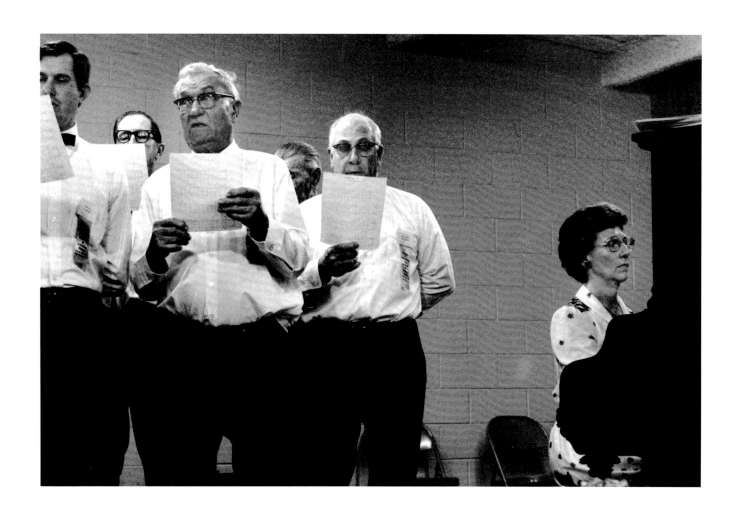

Saengerfest, singing festival

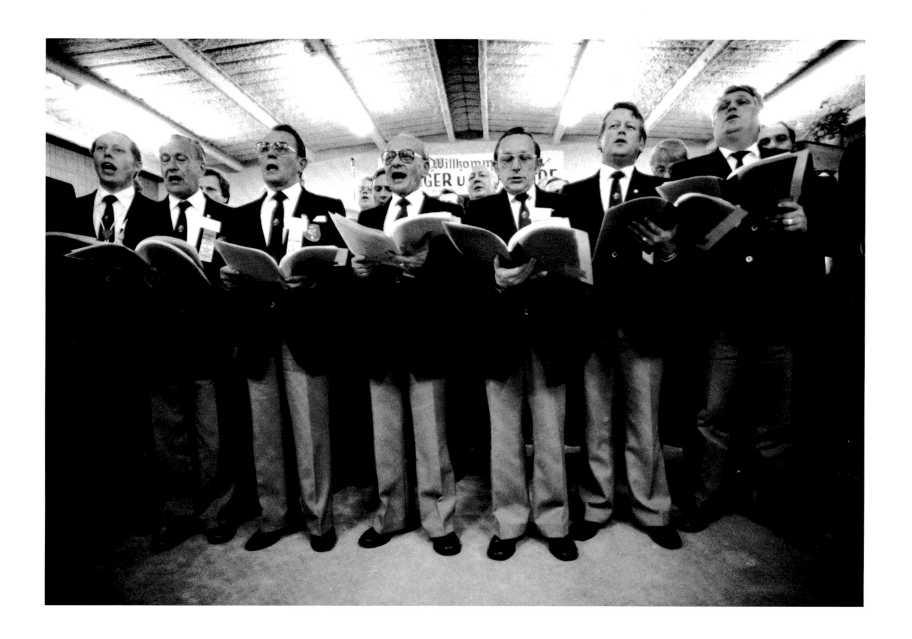

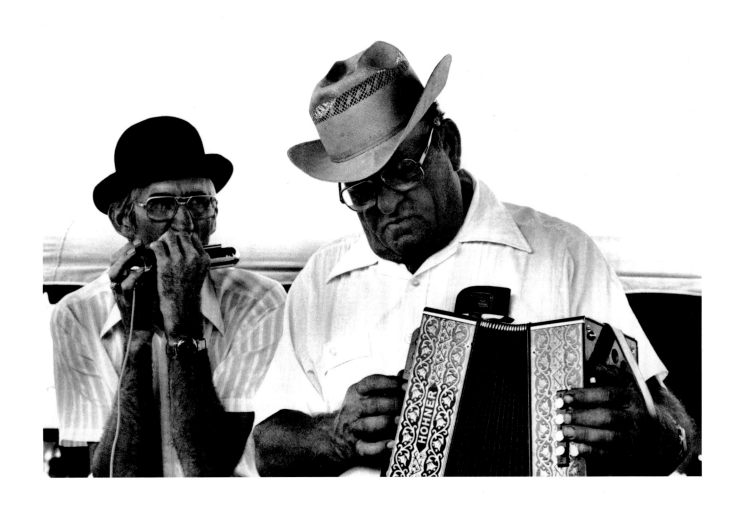

Stonewall Peace Jamboree, Gillespie County

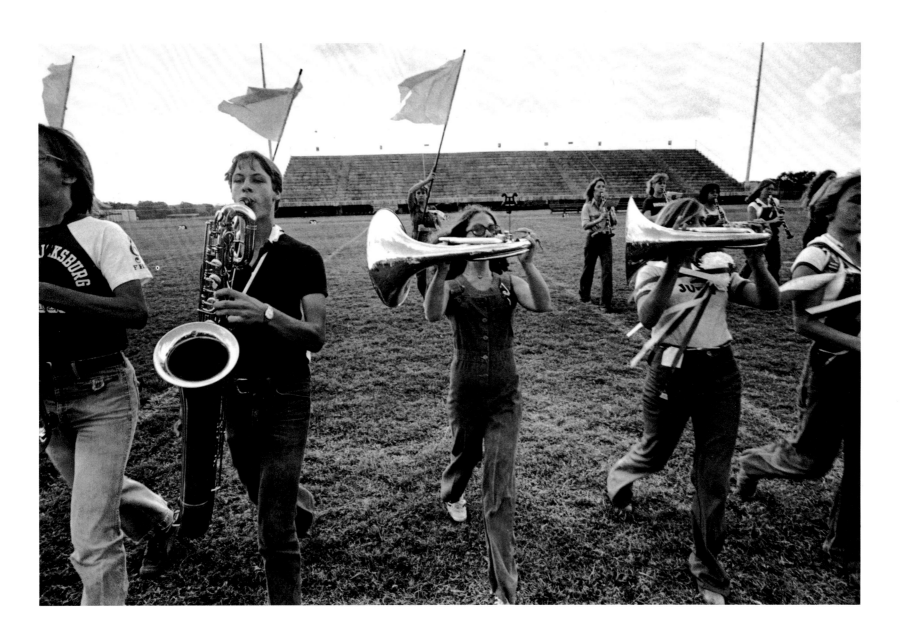

Band practice, Fredericksburg High School Band

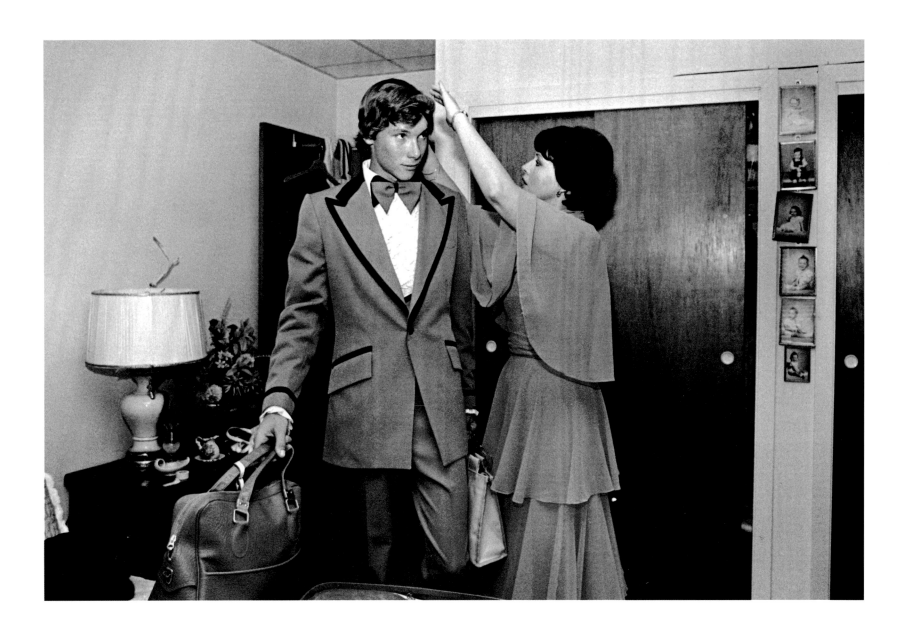

Weddings, Fredericksburg

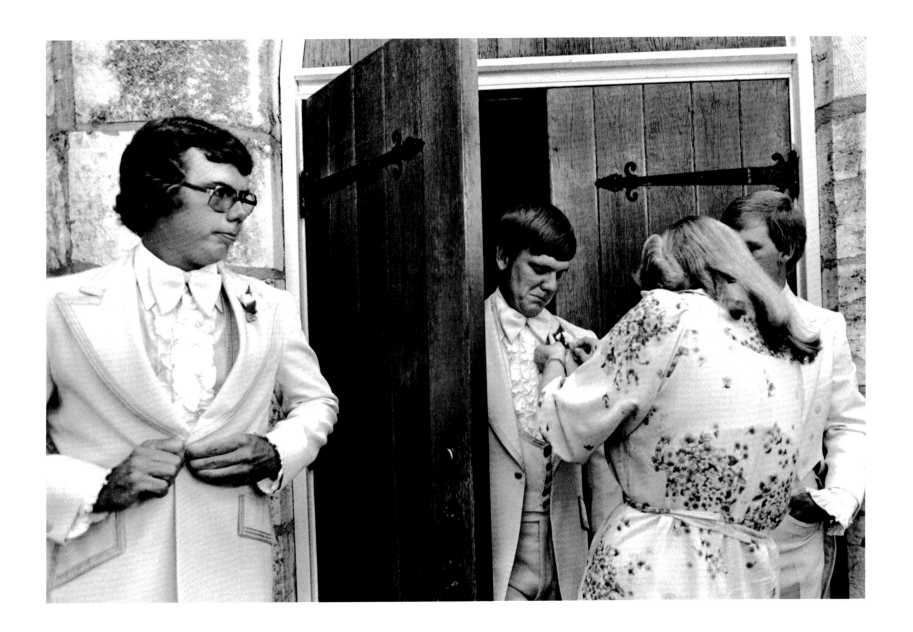

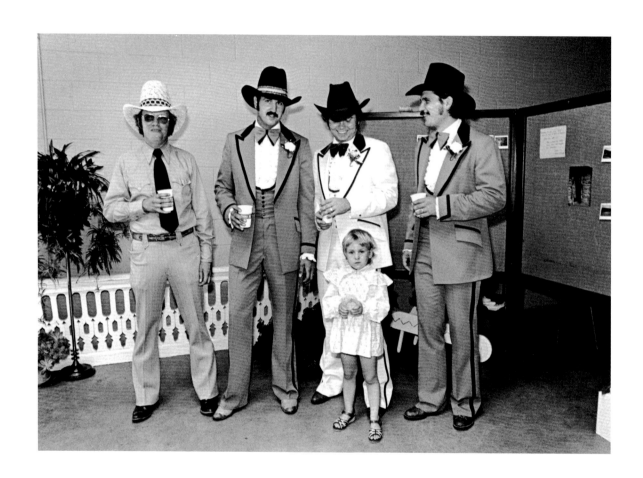

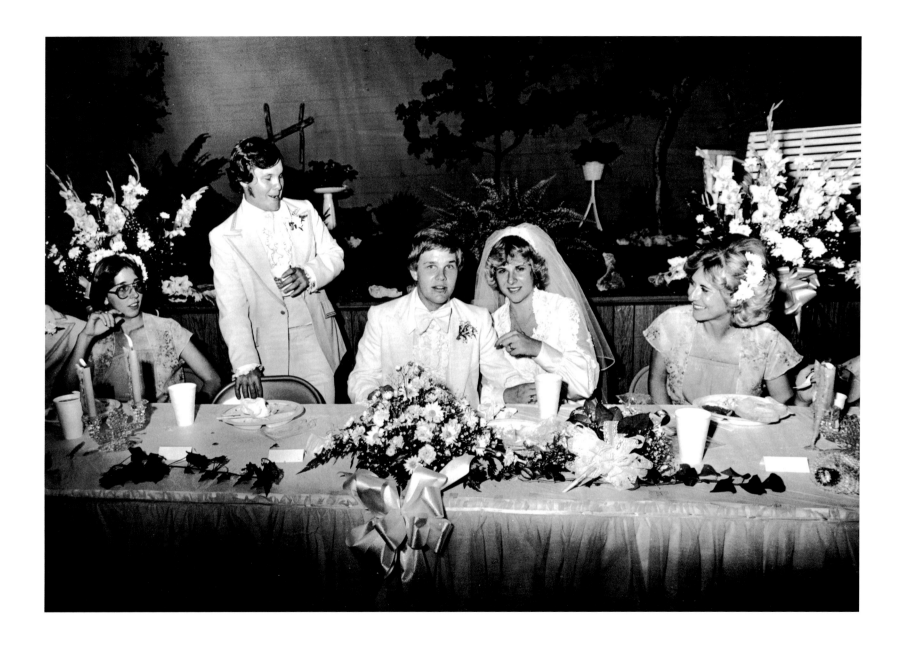

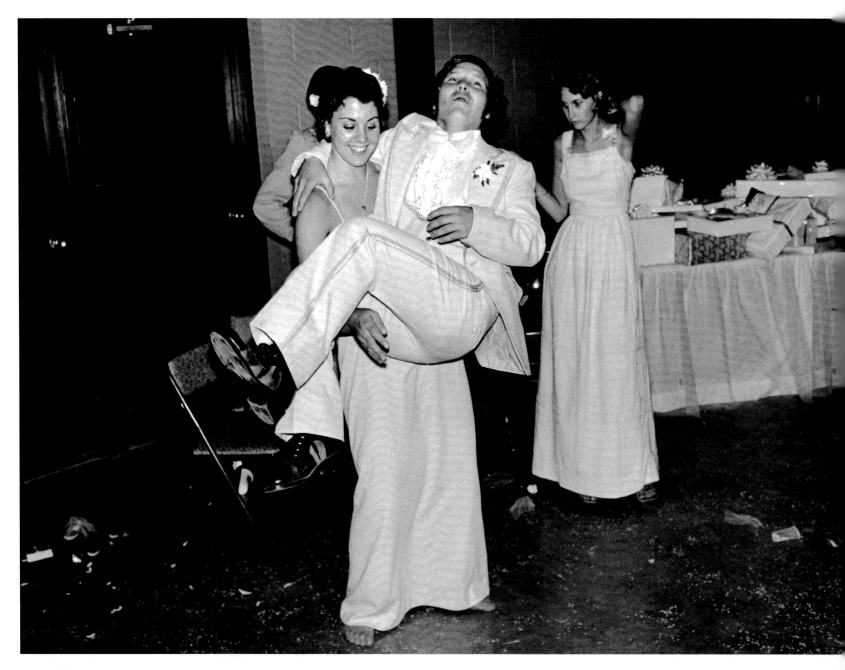

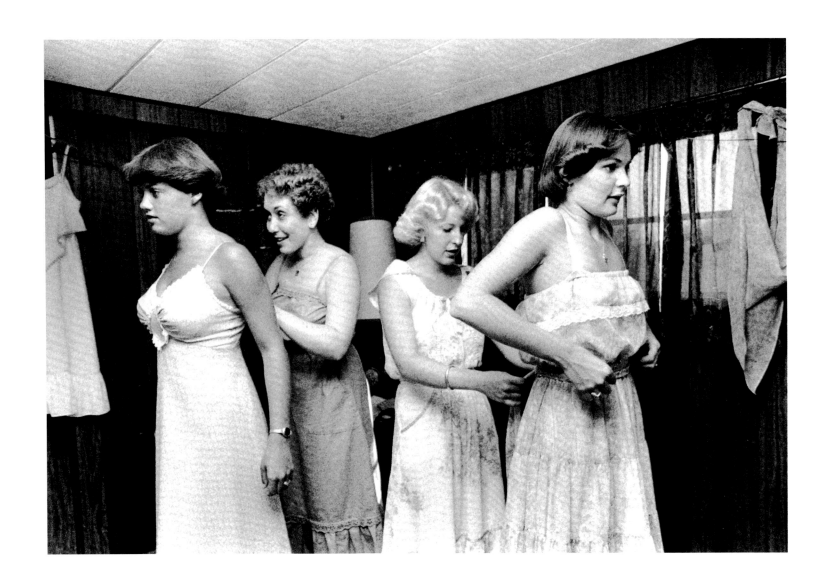

Beauty contests, Fredericksburg and Stonewall

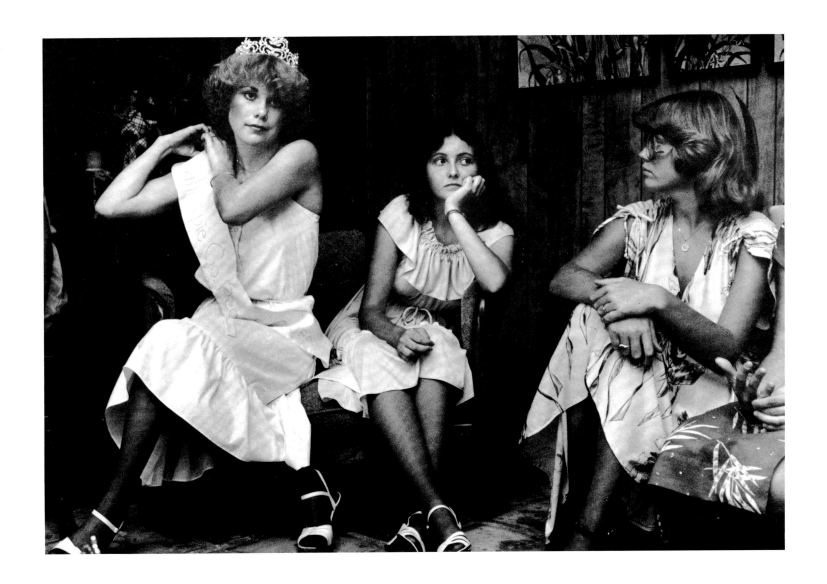

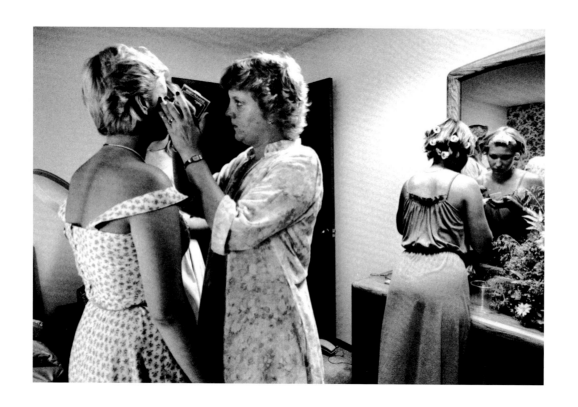

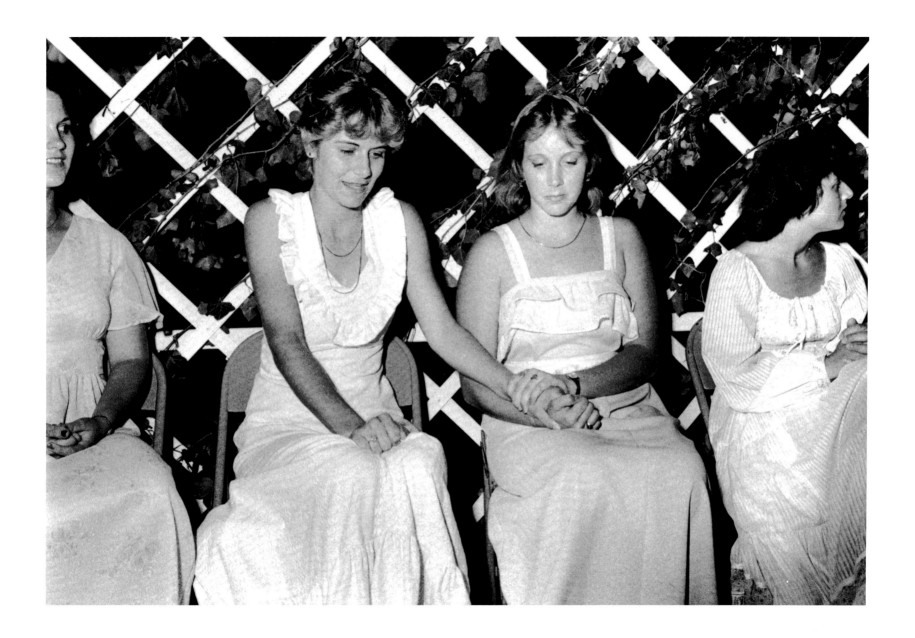

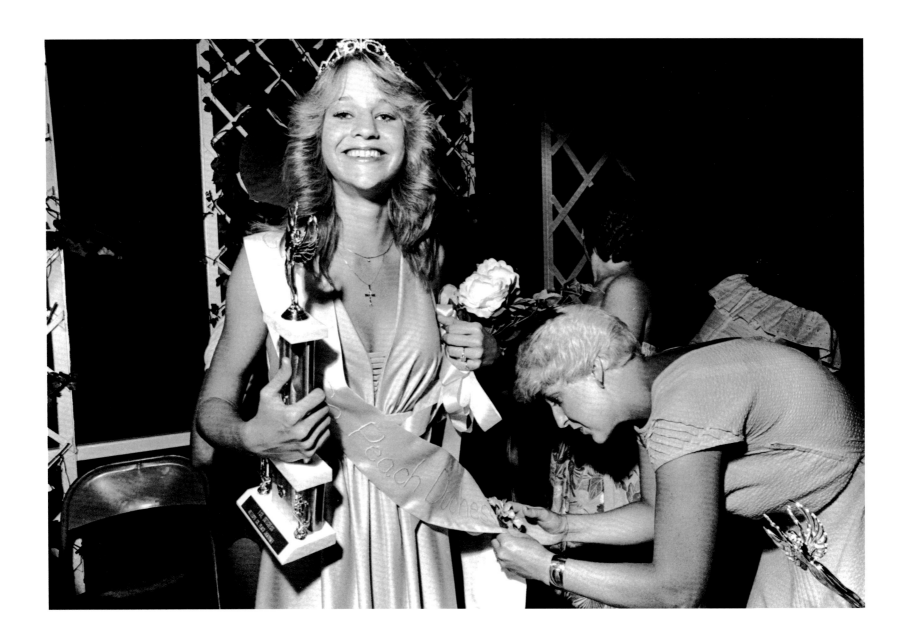

5.

Transformations

. . . and remembrance becomes theatre.

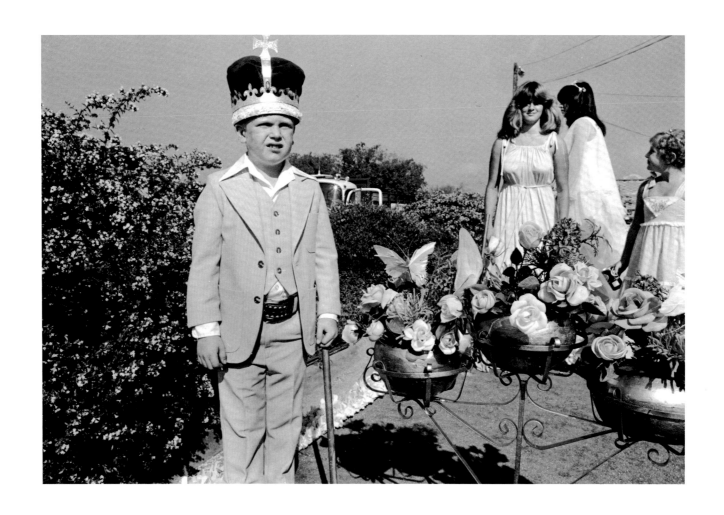

County Fair Parade, Fredericksburg

116

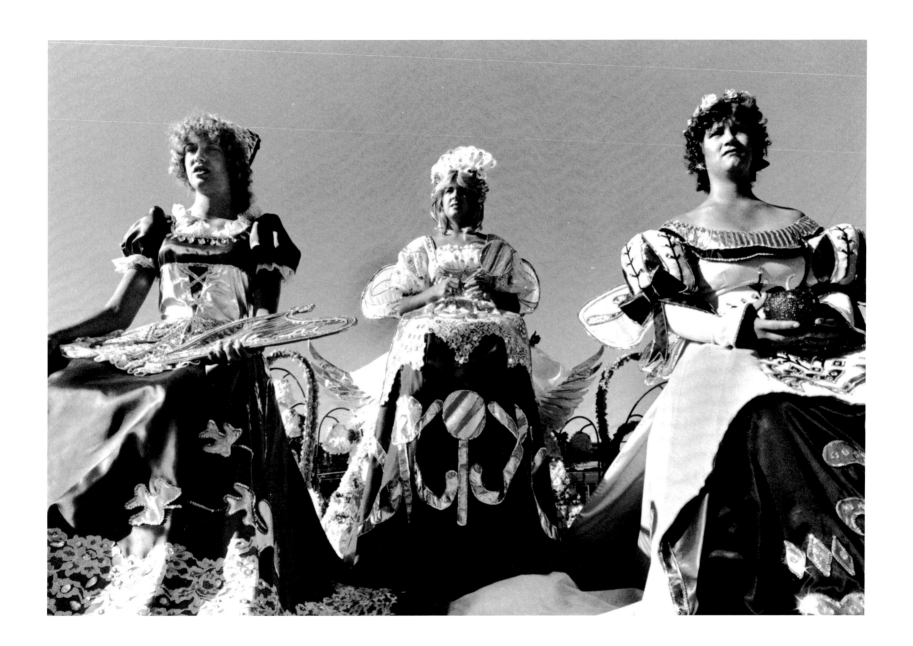

Fredericksburg Easter Pageant

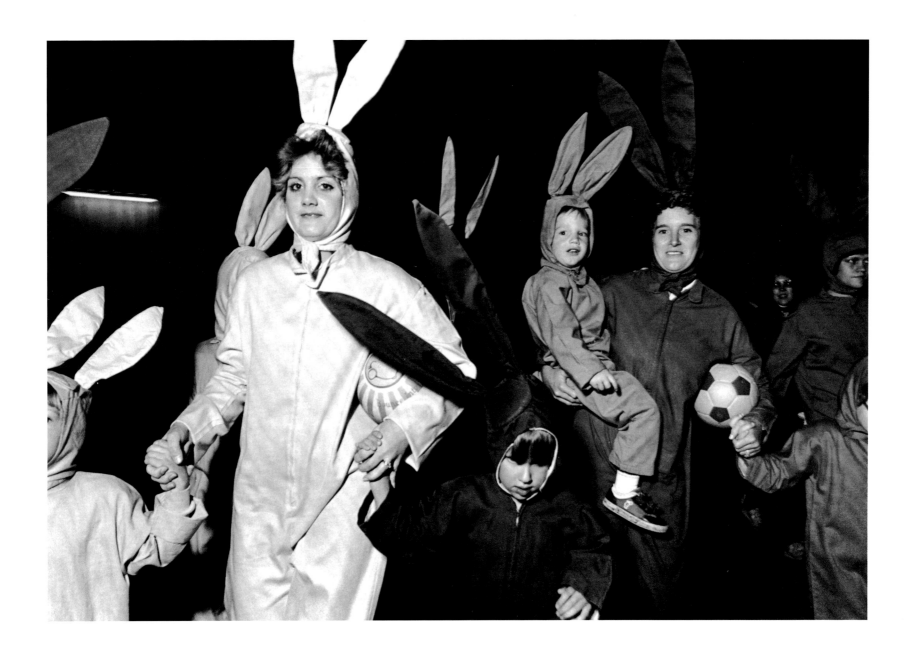

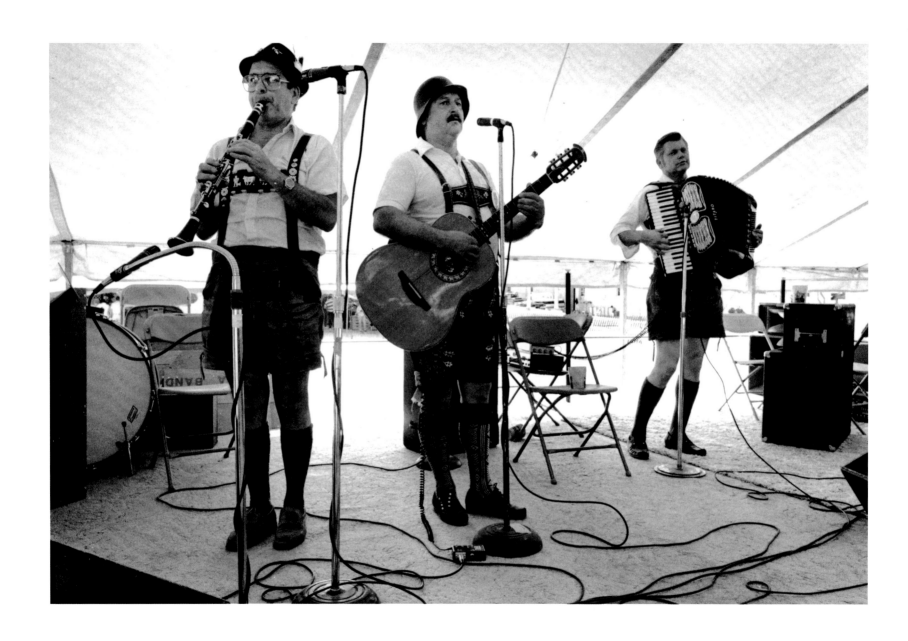

New German band, Old Night in Fredericksburg

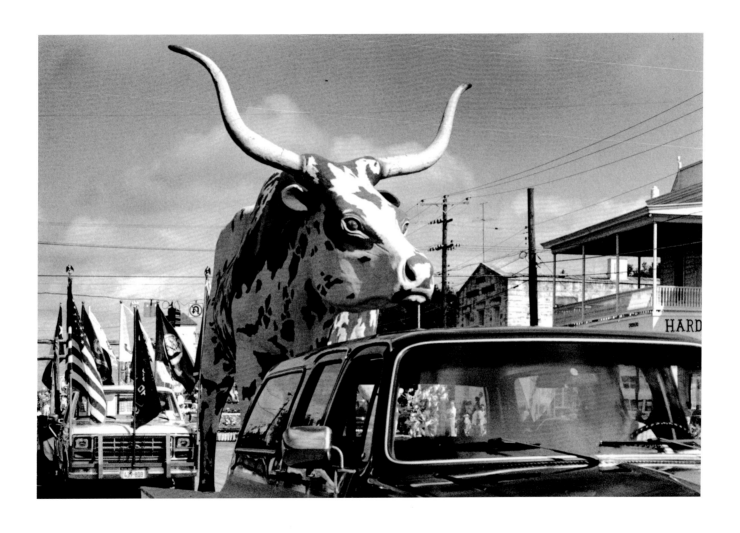

County Fair Parade, Fredericksburg

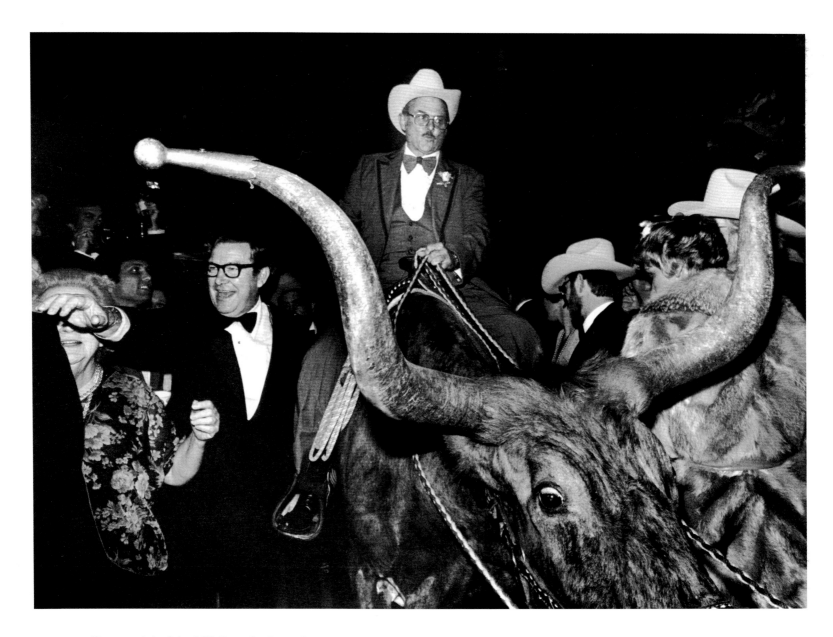

Centennial of the YO Ranch, Kerr County

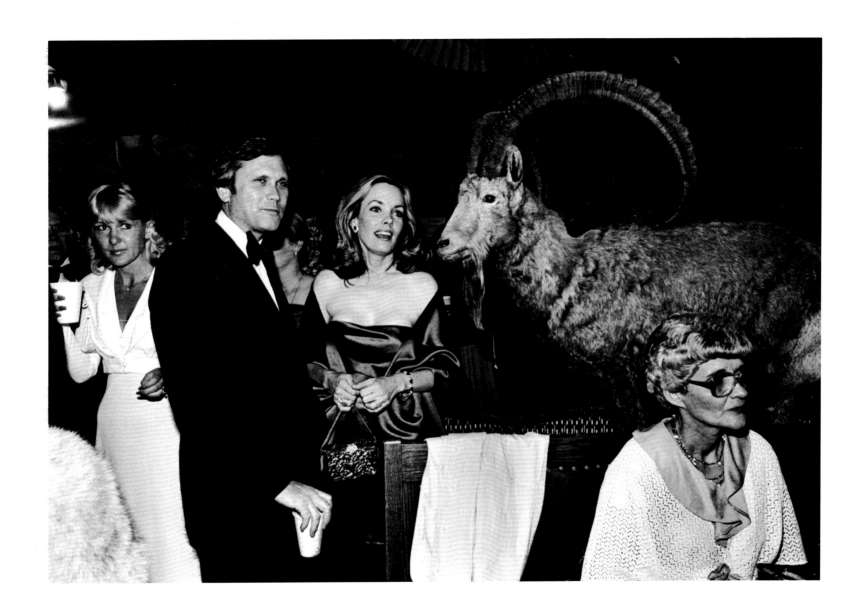

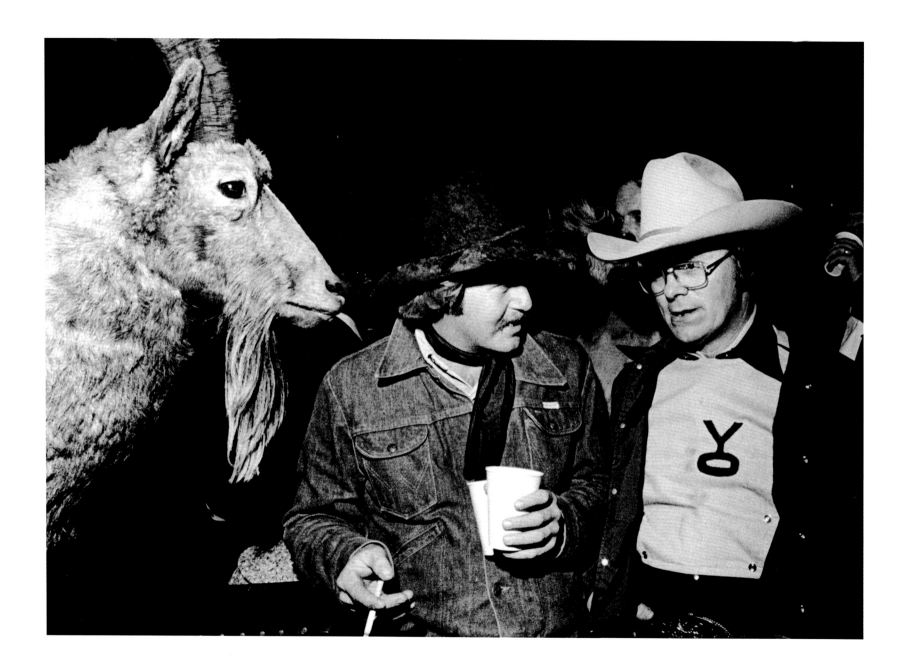

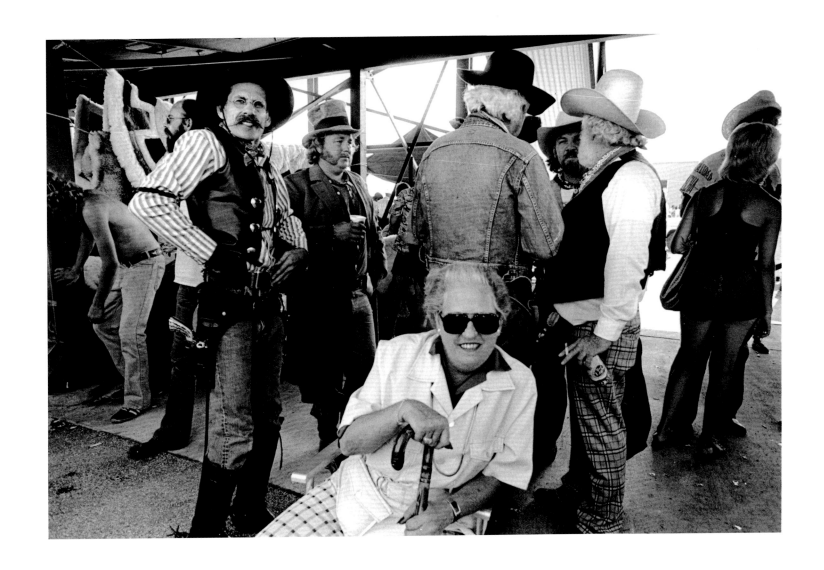

Fredericksburg World's Fair

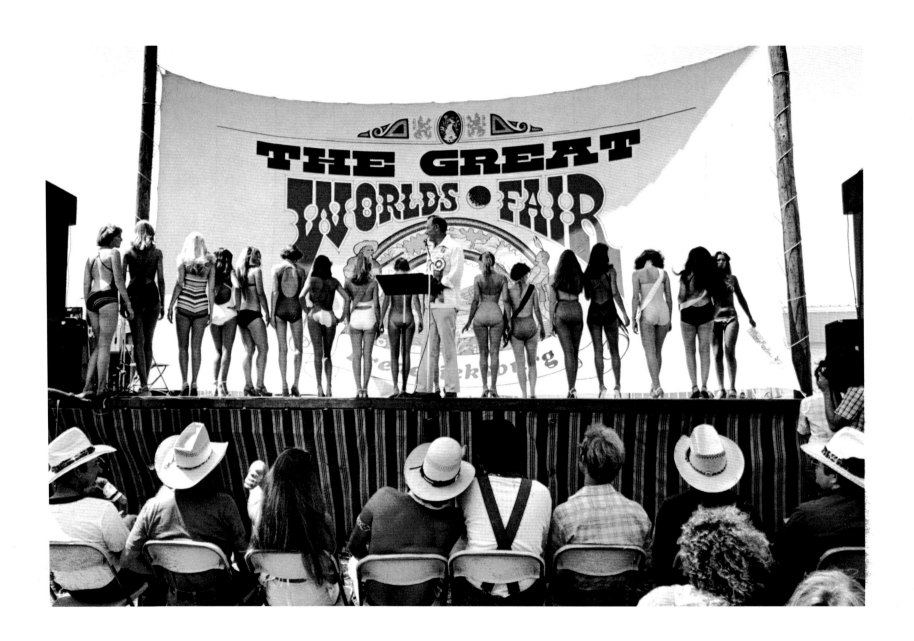

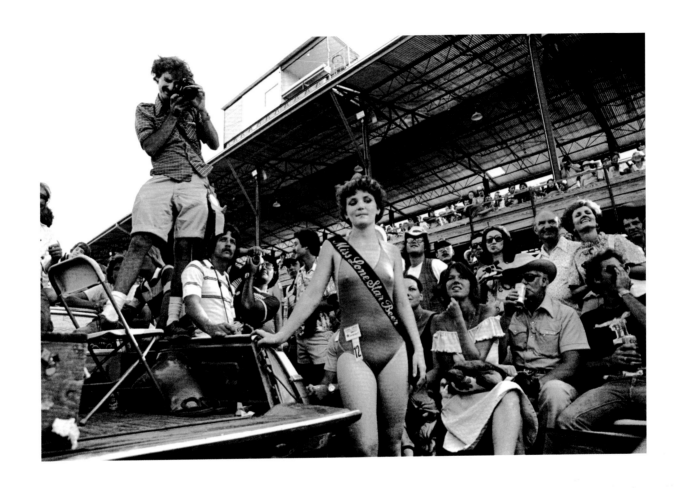

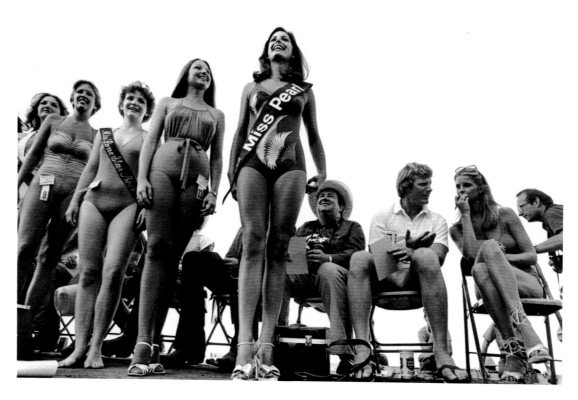

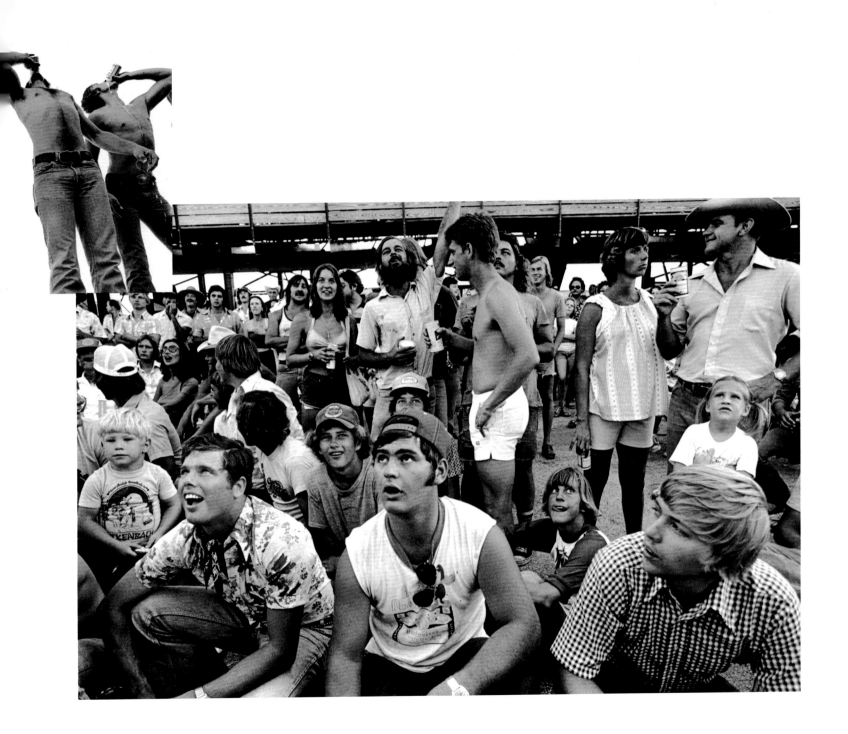

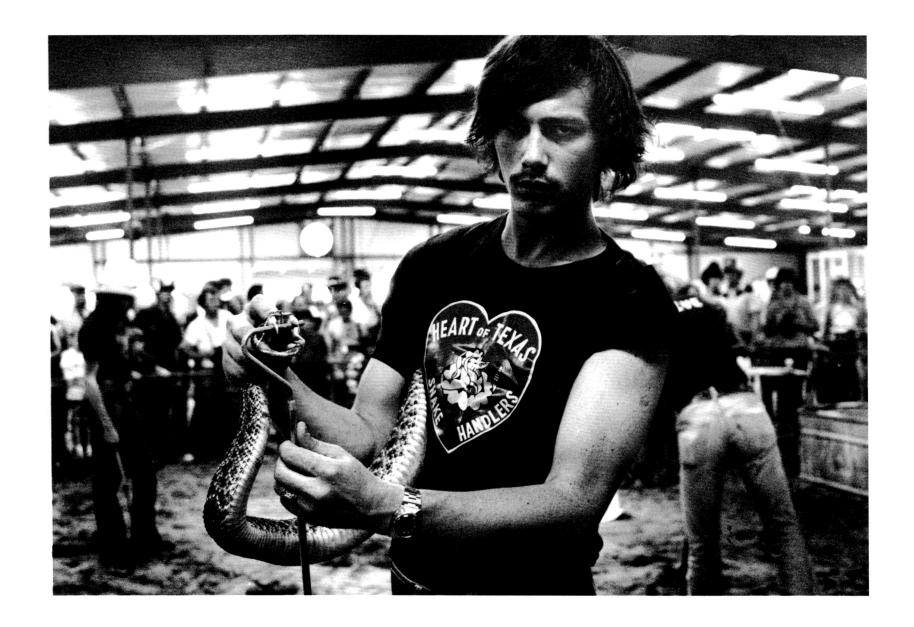

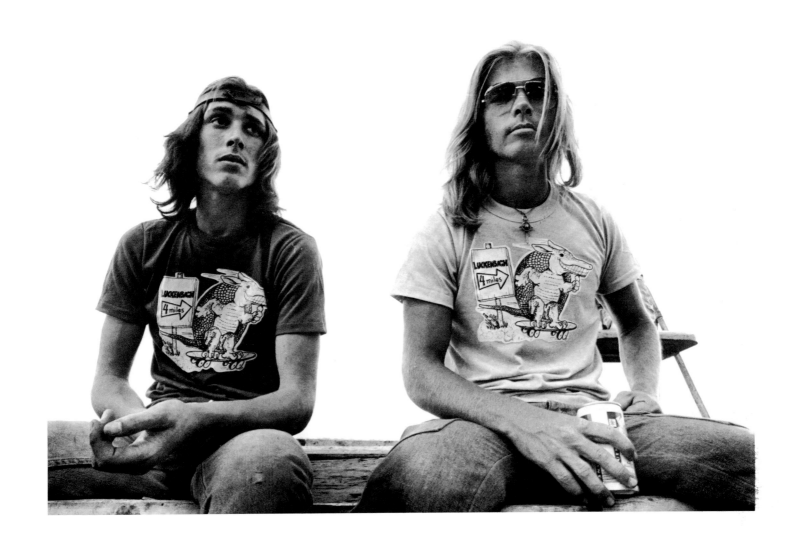

New Year's Eve, the County Fairgrounds

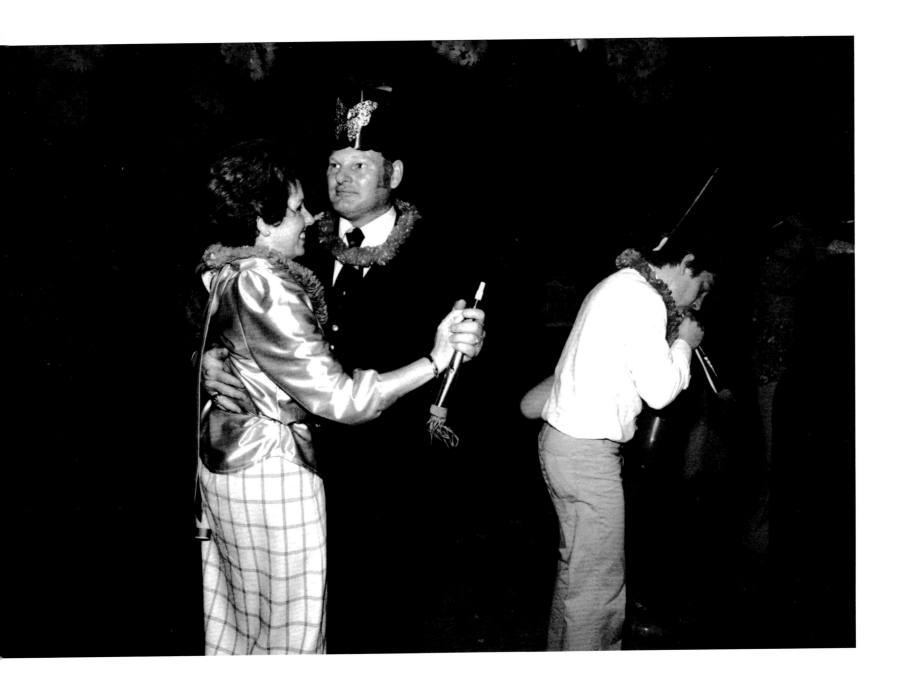

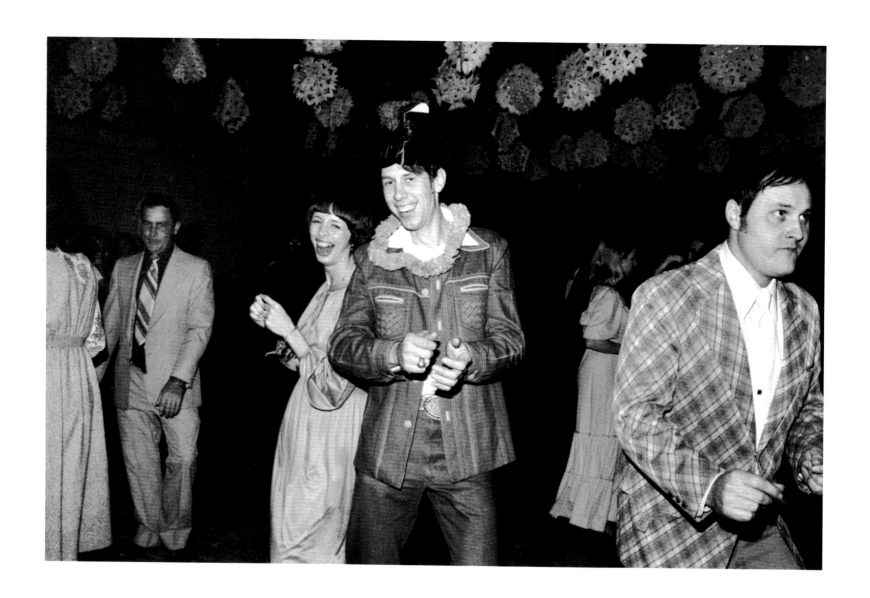

134

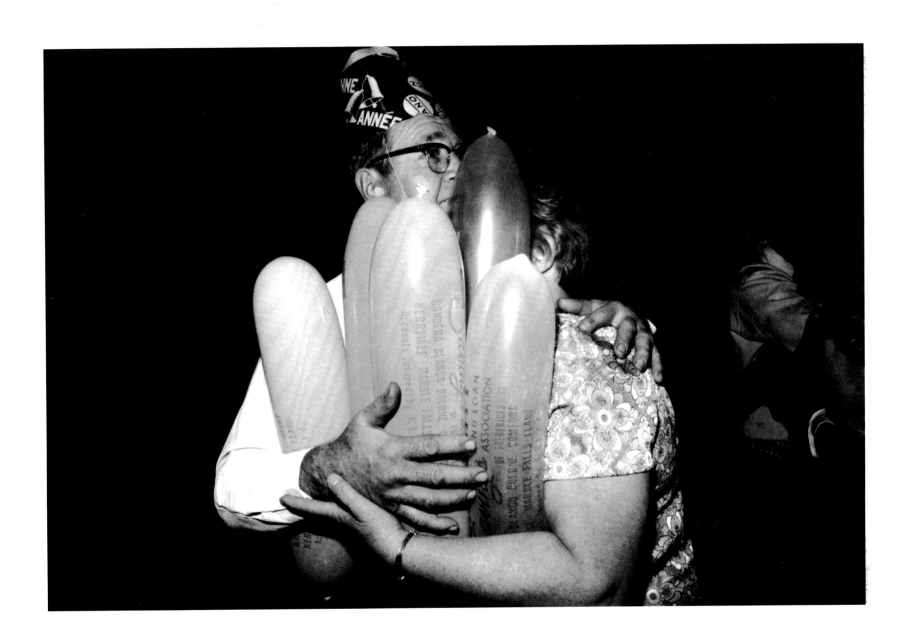

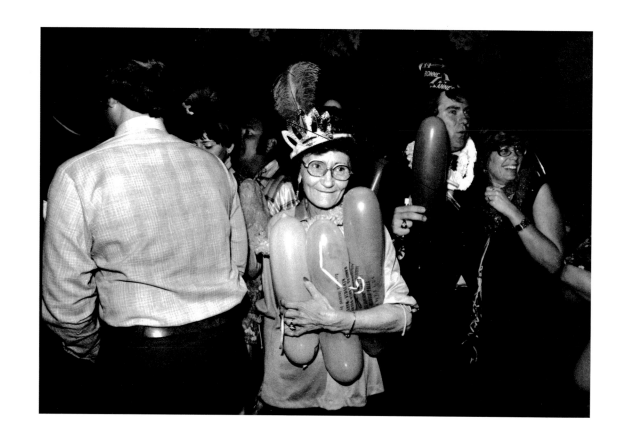

Photographers' Postscript

WHEN WE FIRST WENT to the Hill Country, we stopped at a gas station at dusk. There had been a sudden shower, the roads glistened, and a pink light was slowly settling over the tops of the hills. A man came out of the station, and the three of us stood silently looking at the hills. Then he turned to us and said: "You know where you are? It's God's country."

It's a term we wouldn't use, but he was right. There is something peculiarly compelling about the Hill Country. When people talk about the lure of the hills, that's what they mean. The Hill Country is not grandiose or dramatic or overpowering, but there's nothing quite like it. Perhaps the attraction is its contradictions, the ways the land has challenged human settlement and conquest.

When we first went to the Hill Country in 1971, the people attracted us because they seemed solid and enduring—part of the hills. The Hill Country became a part of our own coming to terms with history and heritage. We came to Texas, symbolic center of the American dream, to scratch away at the surface and see what lay underneath. We wanted to begin to understand the diverse people and forces that had combined to make the American experience. When we had learned enough to identify these forces in Texas, we went to look for ourselves. We went first to the old cotton frontier of East Texas, then to the German counties west of Austin, then the border towns of South Texas, and west to the mountains of the Trans-Pecos.

When you live in a place for several years and visit it for many more, and in the process make yourself generally intrusive, there are always more people to thank than is possible. Many people in the Hill Country have helped us over these years: Edwin and Paula Rausch, who gave us a back pasture and a creek and the kind of openness that made our entrance into their community much

easier than it might have been; Erna Heinen, who gave us valuable criticism and many hours of good conversation; our neighbor, Mrs. Schuh, who stood watch over us for many months; Mr. and Mrs. Theo Knopp, across the street; Mr. and Mrs. Walter Doebbler; Norma and Henry Frantzen; Joe and Anne Frantzen; Norman and Fred Dietel; Karen Oistrach; the Giles family, Palmer, Edith, Robin, and Vicky, who showed us the best side of ranch life; Tim and Dusty Koock; Finn Alban; Shatzie Crouch; Gloria Hill; Mark Weiser; and Joan Harris. And there were those outside the Hill Country: Dr. Robert Calvert, Lonn Taylor, Jim Colson, Ed Sharpe, Petra Benteler, Robert Washington, and Gay Block.

We would particularly like to thank members of the Schützenfest clubs, the Old Teamsters Reunion, the Hermann Sons Choir, and Pehl's Band, as well as the many families who allowed us to photograph their homes, work, and celebrations . Funding from the National Endowment for the Humanities and the Lecomte de Nauy Fund made the fieldwork possible.

In all such projects, there should be a sense of reciprocal involvement and responsibility. The German Americans of the Hill Country have done more than their part for us. We hope we have done right by them.

The Photographs

Page 5

Live Oak community, Gillespie County, was one of the first settlements founded in the German Hill Country, in 1848. In 1854 it built one of the first German cultural societies, the German Society for Good Fellowship and Promotion of Information, the purpose of which was to build a library, keep newspapers, and exchange information on literary, political, and agricultural matters. (Kilman Collection)

Page 6

The Carl Durst family, one of the first families to go to Texas with the Adelsverein. They emigrated from Dattenhausen, Oberaut Tübingen, Wurtemberg, in 1846. Most of the Adelsverein settlers were

farmers and artisans in northwest Germany—first from Hannover, Nassau, and Hesse. Later settlers came from other parts of Germany, primarily Westphalia, Holstein, Mecklenberg, Wurtemberg, Bavaria, and Baden. In addition to these immigrants, there were two groups of German intellectuals who emigrated in 1846 and 1848. They were Freethinkers, communitarians, and political revolutionaries from Berlin, Heidelberg, Darmstadt, and Giessen. Germans were the largest European immigrant group to settle in Texas. (Collection of Marcella Weyerhausen)

Page 7

Sheep ranch, Edwards Plateau. Many German farmers kept sheep, but large-scale sheep ranching did not take place until the early 1880s. These German settlements became some of the most important wool-producing areas in Texas and the United States in the 1900s. (Kilman Collection)

Page 8

Early Hill Country school, Guadalupe County, with teacher Herman Dietel. German settlers organized schools in the late 1840s shortly after their arrival. They were strong believers in free, nondenominational schools and became early advocates of state funding for public education, which did not become a reality until the late 1880s. (Sophienberg Memorial Association Archives, New Braunfels, Texas)

Page 9

The "Marienkirche," St. Mary's Catholic Church, Fredericksburg. Started in 1860, the building of this church took the efforts of most of the settlers in Fredericksburg. It was built without an architect, and the limestone was quarried and cut by hand from the surrounding hills. It was completed in 1863 and became recognized as one of the finest examples of German Gothic architecture in the country. German settlers were predominantly Catholic and Lutheran. (Kilman Collection)

Page 10

Schuetzenbund, marksmen's association, Gillespie County. The Adelsverein settlers brought the tradi-

tion of shooting clubs and competitions with them from Germany and organized them in the Hill Country as early as 1849. The competitions, first between neighbors, then communities, and finally, in the 1890s, county-wide associations, were held on the Saturday and Sunday closest to August 1 to take advantage of the full moon. The shooting clubs were among the many organizations formed by German settlers, who also began associations for singing, dancing, political debate, agricultural improvement, and mutual aid. (Kilman Collection)

Page 11

Brass band, Fredericksburg. Music was an important part of German Hill Country life. Singing societies were started in the early 1850s, and brass oompah bands became popular (and affordable) in the 1880s and 1890s. (Kilman Collection)

Page 12

Card game, New Braunfels. Card playing was an important pastime for Hill Country Germans and was fiercely defended against criticism from fundamentalist Anglo-American Baptists and Methodists, who decried the games. The German way of spending Sunday with cards, singing, dancing, and sports often shocked Anglo-American settlers, who adhered to their Puritan Sunday. Skat, pinochle, and dominoes ("42") were favorite games, with the German game of skat being the most popular and often described as "the noble game." (Sophienberg Memorial Association Archives, New Braunfels, Texas)

Page 13

Sisters, Mason County. In many turn-of-the-century German family albums, young women were photographed with books. But few German women in the Hill Country were encouraged to finish high school, let alone go to college. (Collection of Marcella Weyerhausen)

Page 14

Wedding, Gillespie County. (Collection of Marcella Weyerhausen)

Page 15

Second generation, Gillespie County. (Collection of Marcella Weyerhausen)

Page 16

German homestead, Edwards Plateau. (Pioneer Memorial Collection)

Page 43

The third generation, Grapetown. Paula and Edwin Rausch on the porch of their family homestead. Their grandfather settled in the Hill Country in 1851 with his two brothers. Thirty years later, they quarried and cut the limestone for the two-story house. It took them two years to build it. Grapetown is one of the earliest settlements, founded in 1854. (1972)

Page 44

Edwin Rausch, Grapetown. (1971)

Page 45

Paula Rausch making *kochkäse*, a cooked clabber cheese, in her kitchen. (Grapetown, 1972)

Page 46

Mr. and Mrs. William J. Frantzen at the gate of their farmhouse on Lower South Grape Creek. (1971)

Page 47

Mr. and Mrs. Carl Reinhard Frantzen on the porch of the old homestead bought in 1867 in exchange for horses. (Luckenbach, 1971)

Page 48

Emil Eberle, one of the last old-time German wine makers, Fredericksburg. Almost all German

farmers used to make beer and wine for private use. There was a commercial brewery founded in the Hill Country as early as 1850, and the last of the traditional German wineries went out of business in 1950 in Fredericksburg. Vine clippings were brought from Europe in the 1800s, but they did not do well. Most of the local wines were sweet and made by combining the abundant wild mustang grape with berries. Today there are attempts to establish a new viticulture industry in the Hill Country. (1972)

Page 49

Clara Luckenbach, great-grandniece of the founder of Luckenbach settlement, at the family farm. The Luckenbach brothers came from Marienberg, Nassau, in the 1840s and helped start the Luckenbach community in 1855. (1972)

Page 50

Alfred Frantzen having an afternoon beer at Luckenbach store. The old Engel country store and post office was a gathering place for older farmers, who would spend time playing dominoes and drinking beer. This store was the inspiration for the country-western music hit, "Luckenbach, Texas." (1971)

Page 51

William Frantzen with his *schuetzen* target rifle in the kitchen of his home. Mr. Frantzen was the *Schuetzenkoenig* or the "king of marksmanship," for many years. (Fredericksburg, 1972)

Page 52

Paula Rausch feeding cattle in the evening on the old homestead. (Grapetown, 1971)

Page 54

Off Pecan Creek Road, northern Gillespie County. Limestone outcroppings. (1985)

Page 55

Off Crenwelge Road, northern Gillespie County. Such motts of scrub oak, brush, and limestone are typical landscape of uplands on the Edwards Plateau. (1985)

Page 56

Merino sheep near Baron's Creek, northwestern Gillespie County. (1985)

Page 57

Near Spring Creek, northwestern Gillespie County. Limestone, caliche, and scrub oak land used mostly for sheep and goat pasture. (1985)

Page 58

Merino sheep near Doss, northwestern Gillespie County. (1985)

Page 59

Branch of Bee Cave Creek, western Gillespie County. The Hill Country is crisscrossed with clear, rocky creeks that can be dry for months at a time and then turn into torrents with a sudden big rain. (1985)

Page 60

Summer shower and sunflowers, Kendall County. (1972)

Page 61

Luckenbach Catholic cemetery. (1971)

Page 62

Luckenbach, Gillespie County. The two-story stone farmhouses and outbuildings are special to the

German Hill Country. The houses were built for permanence. Five to ten years after settlement, German farmers started putting up stone buildings. The bigger, two-story houses were built after the Civil War, and they combined traditional German architecture and Anglo-Southern styles. Rooflines were less steep than on German farmhouses, and the long covered porches with casement windows were an adaption of Anglo styles. (1972)

Page 63

Cherry Spring, northern Gillespie County. This limestone and wood barn was built in the mid-1800s. (1975)

Page 64

Hilda, Mason County. German-American cemetery at the edge of the Fisher-Miller grant. (1986)

Pages 66–69

Angora goat and sheep ranching, Kendall County. Shearing and deworming sheep and goats on the Giles and Spenrath ranches. Some German immigrants brought sheep with them, and they later crossed their animals with Mexican breeds. Sheep and goat raising became a necessity for many Hill Country farmers, and large ranching empires with tens of thousands of animals were built in the late 1800s and early 1900s. For many years the Edwards Plateau was second only to Turkey in production of mohair from Angora goats. German sheep shearers were famous, and a good shearer could handle about 100 to 150 animals a day. Requirements were "a strong back and a weak mind," according to old-time shearers. (1979–80)

Page 70

Joe and Anne Frantzen at their farmhouse in Luckenbach. Joe Frantzen is a fourth-generation German-American farmer. Family, including numerous relatives and in-laws, has been a central focus of community life in the Hill Country. (1971–72)

Page 71

Mr. and Mrs. Alfred Frantzen, Fredericksburg. (1971)

Page 72

Old Teamsters Reunion. Because so many of the German settlements in the Hill Country were far from markets and railroad connections were almost nonexistent, German teamsters were the commercial lifeline for this part of Texas. In the nineteenth century they carried cotton and farm produce as far south as the Mexican border. Few of the old-time teamsters are still living, but the descendants gather to celebrate their memory with barbecue, dancing, and cards every year. (1987)

Page 73

Skat card playing. The game of skat, which was developed by Germans in the mid–1800s, was a favorite pastime in these German-American communities. Somewhat similar to bridge, it is considered one of the most difficult card games to play well. It is a tradition that is kept alive by members of skat clubs like this one in the Hill Country. (1987)

Pages 74–75

Three generations. Robin Giles and his first wife, Vicki, and his parents, Palmer and Edie Giles, of Kendall County. Palmer Giles's father, Alfred, was a well-known English architect who emigrated to Texas in the 1870s and built many public buildings in Texas and Mexico. In the 1800s he became one of a handful of Anglo immigrants to establish a ranch in the Hill Country. Hillingdon Ranch, named after the Gileses' family seat in England, has been in the family for over one hundred years. (1971–72)

Pages 76–77

Schuetzenfest, shooting competitions, at Grapetown and Tivydale, Gillespie County. Shooting and singing clubs are still very active parts of community life in the German Hill Country. Most shooting

clubs are still named for the communities where they were formed in the mid- and late 1800s, and most members are descendants of pioneer members. To be a good shot requires great skill: the targets are set at 200 yards, with the center ring (10 points) being 3.5 inches in diameter. There are two classes, rimfire (.22 caliber) and center fire (all other calibers). Traditionally, competitors loaded their own cartridges, and the guns were handmade and specially designed with extra-long frontsights. Clubs practice spring and fall, but the big competitions are held during the summer. *Schuetzenfests* have kept the tradition of beginning with a parade and business meeting. The shooting competition will go on for two days, along with a picnic barbecue, dancing, and much beer drinking. At the end, the man with the highest number of points is crowned *Schuetzenkoenig,* or king of the contest. The *Schuetzenfest* is a family affair and an occasion for old-timers' reunions. The most significant break with tradition is the very recent inclusion of women as competitors.

Page 79

Fredericksburg. Limestone house at the west end of Main Street. This house is very typical of nineteenth-century residential construction in Fredericksburg: a 1½-story house with steeply pitched roofs, small casement windows, a front porch placed close to the street, and considerable space in the back for outbuildings, kitchen gardens, and an enclosure for animals. (1985)

Page 80

Fredericksburg. The Wilke home, north of Main Street, is one of the larger residential houses in Fredericksburg and reflects an architectural style used in the late 1800s and early 1900s. (1985)

Page 81

Fredericksburg. The Pedragon house, south of Main Street. (1985)

Page 82

North side of Main Street, Fredericksburg. The Fredericksburg National Bank Building was designed by Alfred Giles in 1897–98. Fredericksburg was laid out in 1846 as a market town capable of serving

10,000–12,000 people. It is famous for its unusually wide and long (one mile) Main Street lined by stone buildings. Its long, narrow shape is reminiscent of some German farm villages, but the wide parallel streets and geometric checkerboard layout reflect Anglo-American influences. The planners of 1846 envisioned that farmers would live in Fredericksburg, so town lots were made a half-acre in size to accommodate animals as well as fruit and vegetable gardens. In fact, most farmers eventually left town, and many built "Sunday houses" on the old town lots. (1986)

Page 83

Fredericksburg Radio-Post newspaper, one of the paper's press rooms on distribution day. The great-grandfather of the Dietel family, Frederick Holekamp, was a brickmaker and musician from Hannover. He came over on the first ship sent by the Adelsverein. It was a crowded, twelve-week voyage to Galveston, but he and his wife brought books and furniture as well as farm implements. German newspapers were started in the Hill Country in the early 1850s, and twenty years later almost every settlement of any size had a German/English newspaper. For years, Fredericksburg had two to three weekly papers, and the German-language paper often had the largest circulation. The last German newspaper in Fredericksburg went out of business in 1945. The *Radio Post* was started in 1922 by Norman Dietel's father. It was owned and edited by the family until 1977. (1975)

Page 84

The Fredericksburg Bakery. Baking bread and rolling doughnuts at 5 A.M. The bakery is one of the oldest continuing businesses in Fredericksburg. (1985)

Page 85

Two generations, father and son. The tinsmith business, Otto Kolmeier & Co., was founded in 1896. (Fredericksburg, 1985)

Page 86

Wool Sacks, Inc. Making burlap sacks for transporting mohair. (Fredericksburg, 1985)

Page 87

White Elephant Saloon, Fredericksburg. Built in 1888, this is one of the most distinctive buildings in Texas. It was a saloon for years, and the white elephant was made at the request of the saloon-keeper by a local stonemason from the imprint of a merry-go-round elephant. Fredericksburg was once known for having more saloons along its main street than any other small town in Texas. (1986)

Pages 88–90

The Old Domino Hall, Fredericksburg. This was the favorite place in Fredericksburg for old-timers to go to spend the afternoons talking, drinking, and playing dominoes, skat, or pinochle. The Domino Hall was open every day, and German was spoken as much as English. Like Fredericksburg, every Hill Country town had a tavern, store, or ice house where men customarily gathered to talk and play games. (1971–72)

Page 92

Pat's Dance Hall, Fredericksburg, Saturday night. Originally Seipp's Dance Hall, this place was one of the oldest dance halls in Fredericksburg. By the 1950s and 1960s, country-western music began to replace traditional German polkas, schottisches, and waltzes. Rock and roll has never come close to country-western in popularity here. Every little community in the German settlements had a dance hall, with benches along the walls. The young women would sit along the walls, and between dances the young men would stand together. People remember paying one dollar to go to the dances, and the whole family would go. Children grew up learning how to dance—polkas, schottisches, slow waltzes, two-steps, and the popular "Herr Schmidt." (1972)

Page 93

County Fairgrounds, Fredericksburg, Saturday night. In the old days, hats had to be taken off at dances and put in a check room. Among German Americans, it was the custom never to wear a hat or smoke when dancing. This habit occasioned numbers of saloon fights in the old days when Anglo-Americans would refuse to remove their hats. (1978)

Page 94

Sonic Drive-In, Friday night, Fredericksburg. (1979)

Page 95

County Fairgrounds, antique car fair. This type of event is new. People in the German communities tend to keep old cars because they are practical, not because they are antique. (1979)

Pages 96–97

County Fairyrounds. Gillespie County Fair. German settlers formed some of the first agricultural improvement societies in Texas in the 1870s and 1880s. This fair, started in 1881, is said to be the oldest in the state. It was a way for farmers to get together to show their produce, and prizes were offered for superior crops. In addition to farm projects, tailors showed suits of clothes and shoemakers, fancy boots. Today, the fair is a civic activity for local business people, who are expected to lead the auction bidding for animals raised by young people. (1979–80)

Pages 98–99

Rocksprings Rodeo, Edwards County. Bareback bronc riding and calf roper. Until the last twenty-five years, there wasn't much of a cowboy culture among Germans in the Hill Country. In fact, nineteenth-century German American newspaper editors wrote that cowboys were shiftless and a danger to the stability of community life. Now rodeoing and country-western music have become a new way of life. (1971)

Pages 100–101

Saengerfest, singing festival, Fredericksburg. Hermann's Sons Mixed Choir and men's choir visiting from Germany. A German historian wrote: "The German immigrants who came to Texas brought along an invisible passenger, the German song." The singing societies are among the oldest and most enduring German cultural organizations in the Hill Country. They were formed in every German

settlement. The first singing club was started in 1850, and in 1853 the first state *Saengerfest* was held in New Braunfels. These clubs became a way for people to maintain their language and a pride in their culture. Because there had been political pronouncements at the *Saengerfest* in 1854, during the Civil War these societies were denounced as antislavery and subversive.

The old festivals were two days long, and people came with wagons full of food and bedding. Before each *Saengerfest,* houses in the host town were decorated with wreaths and garlands. Parades began the festival, and dancing went long into the night. Some groups sang classical German *Lieder,* but most sang German folk songs. An old German favorite still sung is the sad farewell song, "Muss Ich Denn." In the past ten years, singing clubs from Germany have been invited to participate in the *Saengerfest.* (1979)

Page 102

Stonewall Peace Jamboree, Gillespie County. The Knutsch Band with Clarence Cornehl playing the accordion and Eugene Hartmann on the harmonica. In addition to brass instruments, the accordion and harmonica were popular with German-American communities here. (1979)

Page 103

Band practice, Fredericksburg High School Band. Continuing the musical heritage of the German Hill Country, Fredericksburg's high school band has been known as one of the best in Texas. "Pride of the Hill Country" is what it is called. (1979–80)

Pages 104–108

Weddings, Fredericksburg. Once a farmer found some land he liked, he tended to stay there. And many German American families tended to stay in the Hill Country. Pioneer families often had six or ten children, the next generation five or six. Weddings are very important, and they generally include several hundred people. (1978–80)

Pages 110–114

Beauty contests, Fredericksburg and Stonewall. Parades and festivals have long been a part of German Hill Country life, but beauty pageants are a recent phenomenon. Winners represent their communities throughout the state, and the competitions are taken very seriously. Classes are given in comportment and posture. Contestants are often asked about their values and plans for the future. (1978–80)

Pages 116–117

County Fair Parade, Fredericksburg. (1979–80)

Pages 118–119

Fredericksburg Easter Pageant, combining Old World tradition with New World fantasy, the "Easter Fires" and its pioneer heritage. In parts of pre-Christian Germany fires were lit in fields to welcome the coming of spring. Later, especially in areas of Lower Saxony, Westphalia, and Hesse, fires were lit on hilltops Easter eve in celebration of Christ's resurrection. After the American Civil War, it became common for farmers in Gillespie County to light Easter fires in pastures and on hilltops around Fredericksburg. In 1948, a local pageant was written to fuse the lighting of fires with another German custom, gathering colored Easter eggs, and the history of Fredericksburg's founding. Comanches, pioneers, Easter fires, and the gathering of eggs all come together. Dozens of children participate as costumed rabbits gathering wild flowers and dyeing eggs in huge pots lit by the fires. As they finish their work, they dance to old German melodies played by an oompah band.

Then there is the story of an Indian maiden about to be sacrificed to bring an end to drought. She is rescued by an Indian brave who tells her about the coming of Spanish missionaries and the "true God." Grateful for her salvation, the Indian maiden covers the hills with wild flowers. Then German immigrants arrive to found Fredericksburg, and the men go off to a peace council with the Comanches. When the council begins, other Comanches light fires on the hills around Fredericksburg to see

that there is no treachery. To calm the fears of their children looking at the signal fires, the German mothers tell them that rabbits have made the fires to dye Easter eggs. They pray for a safe return of their men, who do return with a peace treaty in hand. The pageant ends with hymns and a reminder of the significance of Easter. In fact, the Comanche-Meusebach treaty was one of the most unusual in the history of Indian-American relations because it was never broken. (1984–85)

Page 120

New German band at Old Night in Fredericksburg. (1987)

Page 121

County Fair Parade, Fredericksburg. (1987)

Pages 122–124

Centennial of the YO Ranch, Kerr County. This was a celebration for one of the oldest Hill Country ranches, once famous for its sheep and now for its exotic game, imported from Asia and Africa for weekend trophy hunting. The head of the ranch—Charles Schreiner, Sr.—rides through the living room of the ranch house on a pet Longhorn steer. (1980)

Pages 125–131

Fredericksburg World's Fair. This Wild West fair is put on by enthusiasts of frontier history, with dramatic reenactments of cowboy shootouts, rattlesnake roundups, armadillo races, chicken flying contests, motorcycle stunts, beer drinking, and beauty contests. (1978)

Page 133–137

New Year's Eve, the County Fairgrounds, Fredericksburg. From early days, the Germans of the Hill Country filled December with festivals, and one of the biggest celebrations was the welcoming of the New Year with a big supper served family-style at long tables and with dancing until dawn. (1979)